IMAGES
of America

HORSHAM
TOWNSHIP

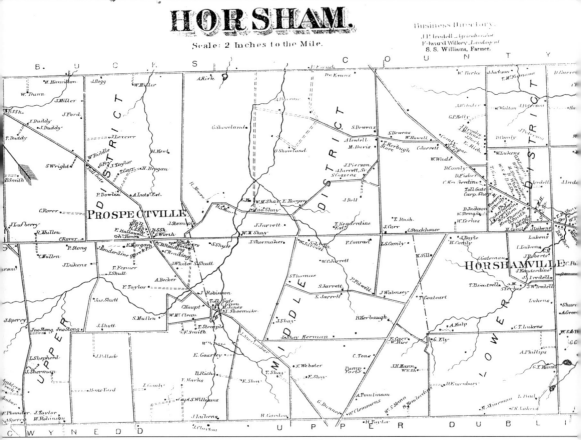

HORSHAM.

Scale: 2 Inches to the Mile.

Business Directory.

J.P. Iredell, Agriculturist
Edward Wilkey, Landscape
S. S. Williams, Farmer.

Shown here is a map of the township of Horsham, which forms a somewhat irregular parallelogram with an average width of slightly more than 3 miles. The average length is slightly more than 5.5 miles, and the total area is about 10,750 acres, or a little less than 17 square miles.

IMAGES
of America

HORSHAM
TOWNSHIP

Leon Clemmer
and the Horsham Preservation and Historical Association

ARCADIA
PUBLISHING

Published by Arcadia Publishing
Charleston SC, Chicago IL, Portsmouth NH, San Francisco CA

Printed in the United States of America

Library of Congress Catalog Card Number: 2003113870

For all general information contact Arcadia Publishing at:
Telephone 843-853-2070
Fax 843-853-0044
E-mail sales@arcadiapublishing.com
For customer service and orders:
Toll-Free 1-888-313-2665

Visit us on the Internet at www.arcadiapublishing.com

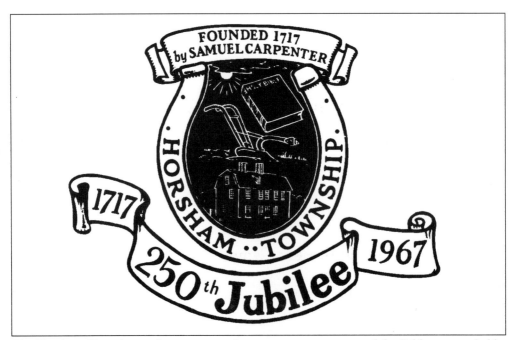

The Horsham Township seal is unique in that it contains a picture of the Bible surrounded by the date of the founding of the township (1717), the farmer's plow, the Keith House, and the sun in the heavens above.

CONTENTS

ACKNOWLEDGMENTS

The Horsham Preservation and Historical Association is honored by Arcadia Publishing's invitation to compile this book of the history of Horsham Township. Such a project could not have been accomplished without the cooperation of many people, many organizations, and many governmental agencies—our thanks to all. The work could not have been accomplished without the help of Erin Loftus at Arcadia. Our thanks also go out to the editor, Leon Clemmer and his committee, Pete Choate, and John Van Steenwyk. For their assistance we also must acknowledge Margaret Choate, Steve Pitcairn, Carl Gunther, Bill Hough, Bill Worth, Hank Haines, Janet Hankin, Capt. Layne Smith at the Willow Grove Naval Air Station, the Wings of Freedom, Betty and Amy Jarrett of Horsham Friends Meeting, Betsy Urffer, David and Kim Noble, Mary Ellen Markloff, Laura Dugan, Sen. Stewart Greenleaf, Maura Gillian, Mary Park, Cassin Craig, Debbie Meloney, Norman and Wesley Ahn, Bill Walker of Horsham Township, Frank Gerome of the College Settlement, Alvan Outland of the Horsham Police Department, and Brian Slyfield of Horsham, Sussex, England. Useful information was found in *The History of Montgomery County Trolleys*, by Harold Cox. Special thanks go to Julia Converse of the Architectural Archives at the University of Pennsylvania and John Pollack of the Annenberg Rare Book & Manuscript Library of the VanPelt Dietrich Library Center at the University of Pennsylvania. Thanks also go to Ben Rohrbeck, Traction Publications, David Rowland of the Old York Road Historical Society, the architectural firm of H2L2, the Whitemarsh Memorial Park, George Meagher, and many more. Special thanks go to Maury Craven, whose love for history led to the writing of this book. His invaluable collection of photographs form the backbone of this publication. We thank him for his years of devotion to the history of Horsham and honor him in memoriam.

INTRODUCTION

The wooded wilderness around Philadelphia, including Horsham Township, was mapped in the 1680s by William Penn's surveyor general, Thomas Holmes. Holmes's map defines two of the township's present boundaries—County Line Road and Welsh Road. It also shows where Horsham Road was to be located.

For many centuries, the local American Indians, who called themselves Lenni Lenape, meaning "original people," used areas like Horsham as hunting grounds. Their villages and their gardens (or fields) were near large streams and rivers. There were villages at Manayunk, Conshohocken, East Falls, and Perkasie; possibly also closer to Horsham on the Neshaminy and Pennypack Creeks.

At regular times yearly, the Indians came out of their villages to hunt and gather food. An Indian family would have a town house and a country place. A township-sized area provided hunting grounds for one or two families. The Indians gave up the land cheaply in exchange for supplies of clothing, guns, powder, and tools. As the settlers moved in, the Indians moved on, without conflict.

Penn's land company sold the whole of Horsham to four investors between 1682 and 1686. The son of one investor, Thomas Palmer, became an early settler. The other investors and their heirs sold the property to a total of 36 original settlers, who took formal possession between 1709 and 1750. These secondary purchasers were farmers, with plots ranging in size from 55 acres to 900 acres. The Horsham Friends Meeting was established on a 50-acre site, which it acquired for the nominal price of five shillings from Samuel Carpenter, one of the four original purchasers. Carpenter is believed to have been responsible for naming the township. He used the name in descriptions of his land, and his birthplace was in Horsham, Sussex, England.

Sir William Keith, the Colonial governor of Pennsylvania, acquired the largest parcel, 1,684 acres, in 1718. His mansion, now known as Graeme Park, was built in 1722.

Horsham Township was formally incorporated and named in 1717. By that time, early settlers were clearing land and operating farms. Accounts of that time indicate that the new residents generally built log houses and then used stone to extend them or to build new dwellings.

Early settlers were concerned with building roads. Most of the area's road system was formed in the Colonial era. Welsh Road was opened in 1712 to provide Welsh farmers in Gwynedd with a route to the early mills along the Pennypack Creek. Keith was instrumental in getting a road built to his plantation in 1722. It started in Willow Grove and followed generally the present course of Easton Road for most of its length. Norristown Road, between Horsham Road

and Welsh Road, was opened in 1723 to provide a way for early Quakers to travel between the Horsham Friends Meeting and the Gwynedd Friends Meeting. Horsham Road was opened in 1735. In 1737, Limekiln Pike was extended from Welsh Road to County Line Road.

A story of the American Revolution relates that in October 1777, a herd of cattle was being driven across country to feed the troops at Valley Forge. Six cows belonging to William Jarrett were added to the herd when it passed through his Horsham farm. Jarrett protested but was mollified several weeks later when George Washington himself stopped for water at the Jarrett homestead and ordered his paymaster to pay for the cows. Earlier in 1777, as the British were about to occupy Philadelphia, the Liberty Bell was transported through Horsham along Easton Road for safekeeping in Allentown. It was part of the cargo in a 700-wagon army supply train.

Local men were enrolled in a state militia during the revolution. They were charged with supplying the Continental army and prevented the delivery of supplies to British-occupied Philadelphia. In the spring of 1778, the militia was camped at the Crooked Billet, near Hatboro, when it was attacked by British raiders.

Early farmers needed mills to grind cattle feed. The Kenderdine Mill, on Park Creek, was built in 1734. It still stands near the intersection of Keith Valley Road and Davis Grove Road. Another mill, built c. 1740, was near Dresher Road. A milling center existed for a time on Limekiln Pike near its intersection with McKean Road. An ox mill was established near there in 1800 by Joseph Kenderdine. It was constructed so that oxen could provide power for the machinery; the building still exists. In 1832, a water-powered mill was built along Limekiln Pike; it was operated until World War I.

As Horsham's farming community matured during the 19th century, several villages emerged. Horshamville was the name for the village near the Friends meetinghouse on Easton Road. It included a tollgate, a hotel, a store, the post office, a woolen mill, and other buildings. The site of a nearby village, Davis Grove, is now part of the Willow Grove Naval Air Station runways.

Horsham maps of the mid-1800s show the village of Prospectville at Limekiln Pike and Horsham Road. A store existed there, and it was still operating during 1960s. An early map designated the area near the intersection of Horsham and Norristown Roads as "Horsham Square," anticipating the present-day Horsham Square Shopping Center.

In its early years, Horsham Township became a prosperous farming community. It stayed that way until the changes of the 20th century. During World War II, Pitcairn Field, a small airfield, was transformed into a huge military facility. Farms gave way to housing developments. Golf courses replaced pastures and fields. Roads became wider. Shopping centers were established. Today, Horsham is part of a suburban mosaic and an expanding megalopolis.

However, we can still see some fields. Old farmhouses give glimpses of former times, and if we look into the woods, we can still imagine a time (over 300 years ago) when the sounds of nature were all that could be heard in the vast forests of Pennsylvania.

One

HISTORIC HOMES

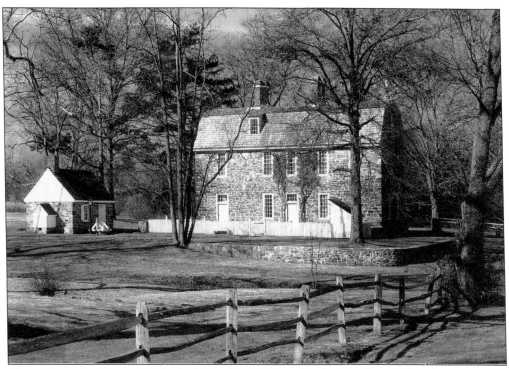

Shown here is Graeme Park, built by Sir William Keith, the first Colonial governor of Pennsylvania. Keith had extensive landholdings in Horsham Township. He lost a great deal of money by financing a number of highly speculative business ventures and was forced to abandon his plans for a malt house. Keith then decided to use the Park House for his residence. He lived there while serving as Colonial governor, and was noted for entertaining on a lavish scale.

BOARD OF SUPERVISORS
OF HORSHAM TOWNSHIP

1025 HORSHAM ROAD
HORSHAM, PENNSYLVANIA 19044

SUPERVISORS:

J. FREDERICK KOHLER, PRESIDENT

ARTHUR W. GREER, VICE PRESIDENT

WILLIAM E. TERRY, SECRETARY AND TREASURER

TOWNSHIP SOLICITOR
PAUL D. NORTH

TOWNSHIP ENGINEER
A. W. MARTIN ASSOCIATES, INC.

PROCLAMATION

WHEREAS, the former home of Governor Keith is an historic landmark in the Township of Horsham, and

WHEREAS, it has been maintained and preserved through these many years as a place of interest to the citizens of the Commonwealth, and

WHEREAS, the most recent owners, Mr. and Mrs. Welsh Strawbridge have so generously given Keith House and its surrounding Graeme Park to the Commonwealth of Pennsylvania and thus guaranteed its permanent preservation, now

THEREFORE, in cooperation with the Horsham Township 250th Jubilee Committee, we, the Board of Supervisors of Horsham Township, do hereby proclaim our profound gratitude to Mr. and Mrs. Strawbridge for their most generous and thoughtful gift to posterity.

J. Frederick Kohler
J. Frederick Kohler
President

Arthur W. Greer
Arthur W. Greer
Vice President

William E. Terry
William E. Terry
Secretary

Welch and Margaret Strawbridge were given a proclamation of thanks during the township's golden jubilee celebration, in 1967. The Strawbridges had just donated the 1722 Keith House and 41 acres to the Commonwealth of Pennsylvania, hoping to continue the preservation of historic Graeme Park.

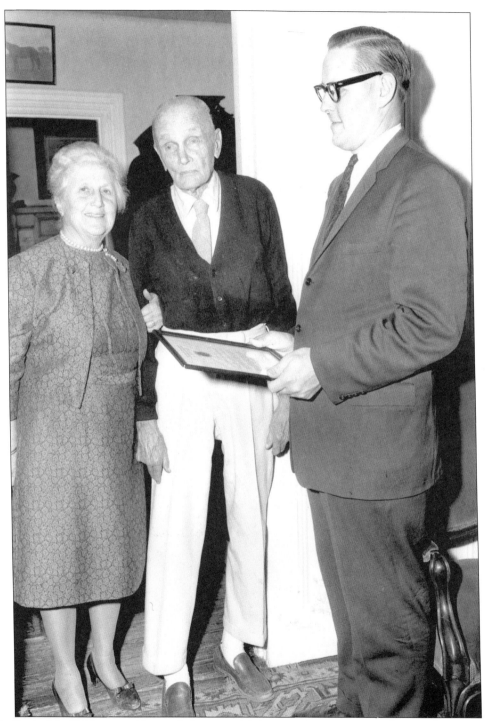

J. Frederick Kohler, president of the township's supervisors, presents the proclamation of thanks to Welsh and Margaret Strawbridge in the living room of their home, now known as the Penrose-Strawbridge House. In the upper left is a picture of River Breeze, the Strawbridges' champion steeplechase horse.

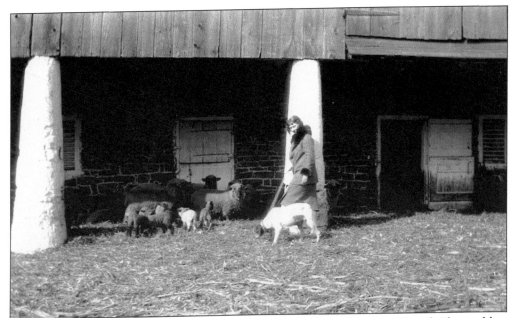

A flock of sheep are shown here under cover of the 1839 barn. Margaret Strawbridge and her dog are keeping the sheep in a group. She raised sheep and used the yarn from their wool to make blankets for the soldiers during World War II. The barn is now the Historic Graeme Park Visitors Center.

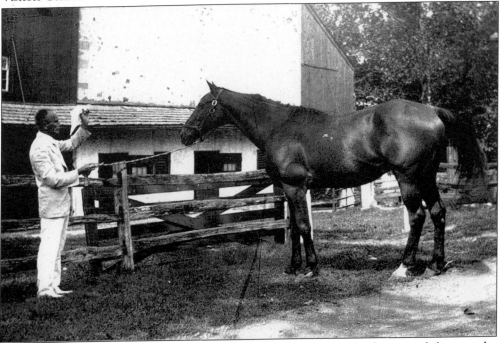

Welch Strawbridge was a gentleman farmer who raised timber and had cows and sheep at the farm on Governor Road. As a hobby, he raised steeplechase horses, including *River Breeze*. This prizewinning horse won 16 steeplechases before being retired. When River Breeze died, he was buried behind the main house with a stone clearly marking the site.

Sir William Keith was born in a baronial home in Scotland in 1680. In 1717, he was appointed the Colonial governor of Pennsylvania. In 1718, he purchased as least 1,200 acres of land in Horsham Township. Keith had not intended to live on the land he had purchased. However, due to his lavish lifestyle and his desire to be popular among the people, he began to ignore the wishes of the widow Penn. In 1726, Keith was removed from his position. In March 1728, he left Pennsylvania and returned to England in order to avoid his creditors. He died a poor man.

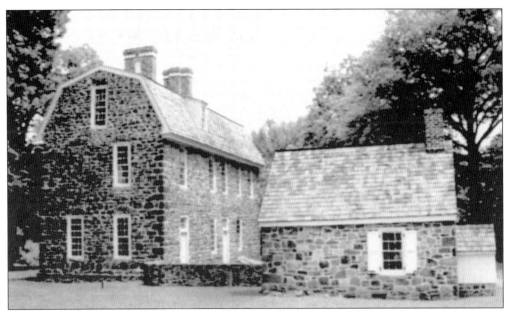

In 1739, Dr. Thomas Graeme purchased the remaining portion of his mother-in-law's (Lady Keith's) estate, which had been his family's summer home. Graeme was well known in Pennsylvania, having held the position of provincial counselor and justice of the superior court. He was cofounder of the Pennsylvania Hospital. In 1739, he became the port physician due to the vast migration of Germans to Pennsylvania.

In addition to the Park House, Sir William Keith constructed three buildings on the property. A long two-story structure was built to the north of the manor house, possibly to house workers for the proposed malt house. Later, this building was used as servants' quarters. A small narrow structure was erected near the bank of the Park Creek, and a large barn was built on the approximate site of the present barn. An area of 50 acres along the Park Creek was set aside for a deer park.

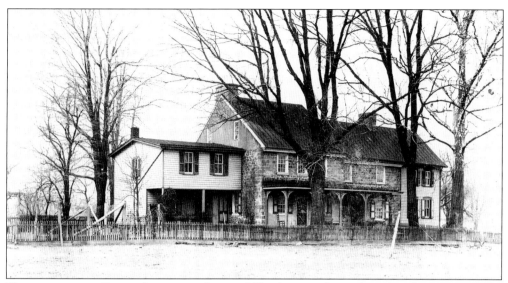

There were many Jarrett farms in and around Horsham in the 18th and 19th centuries. This one was more than 400 acres, with 200 in Horsham and 200 in Warminster. The house, at Meetinghouse and County Line Roads, was demolished before World War I to make way for new homes.

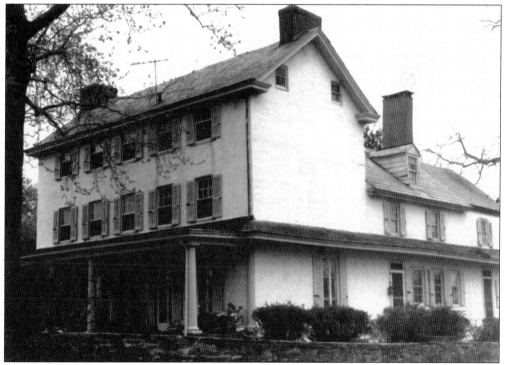

The Penrose-Strawbridge farm sits adjacent to Graeme Park, a state owned and operated park. The histories of these properties are intertwined. In 1801, Samuel Penrose purchased the 204 acres of land known as Graeme Park from Dr. William Smith, a nephew of Elizabeth Graeme Ferguson. Thus began a 120-year history of farming by the Penrose family. In 1810, rather than adding to the Keith House, Samuel Penrose built a separate house.

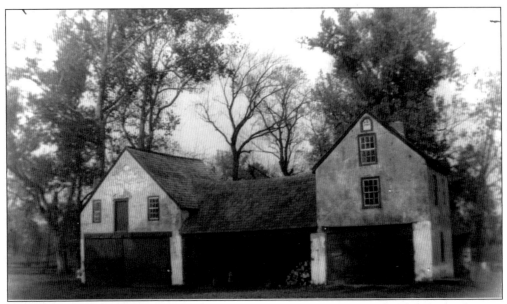

William and Hannah Penrose made many improvements to Graeme Park. They built a barn in 1829 and another in 1839. In 1830, they built a second floor above the pre-1810 cabin, and in 1858, they added the present-day kitchen. The 1830 date plaque is still visible. In April 1865, Abel Penrose became the third generation of Penroses to own Graeme Park. The Penroses continued to preserve the Keith House and gave tours to the public.

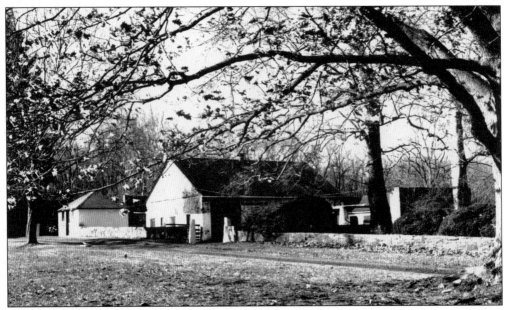

The barn, stables, and the milk house are shown here at the Penrose Strawbridge farm, adjacent to the Keith House. When the Strawbridges purchased the Penrose Farm, 125 years of farming at Graeme Park ended.

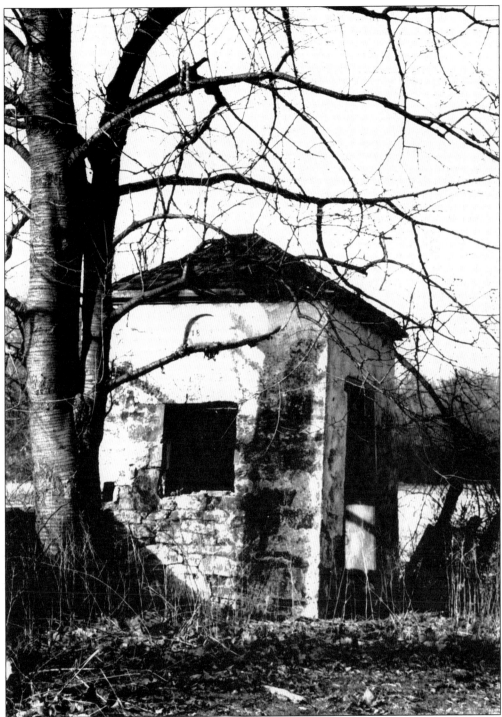

Every farm and home had an outhouse, also known as a necessary, prior to indoor plumbing. The one at the Penrose farm was unusual because it was masonry. With the installation of indoor plumbing, Margaret and Welch Strawbridge converted the necessary to a garden, or potting, shed.

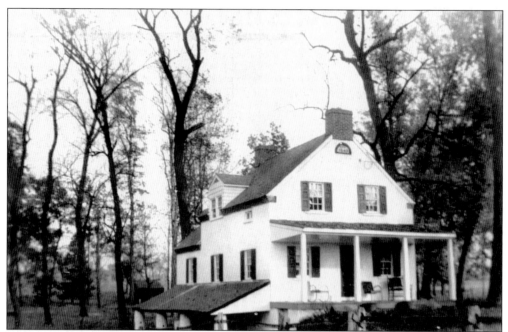

Welsh and Margaret Strawbridge proved to be dedicated to the preservation of Graeme Park. Between 1929 and 1952, Welsh Strawbridge added more to the original 204 acreage of his property, but in 1957, he was forced to sell 41 acres to the federal government for the expansion of the Willow Grove Naval Air Station. In 1957, the Strawbridges gave the land and buildings that make up Graeme Park to the state to preserve forever the original Keith House.

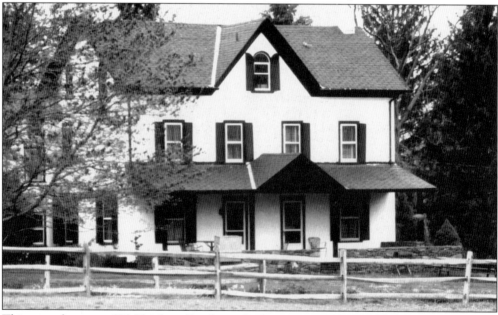

This stone house, at 801 Horsham Road, was built prior to 1797, possibly by Thomas Nixon. Nixon was living in the house in 1797. He and his wife later donated land to the Babylon School Board of Trustees so that a new school could be built for the village of Babylon. That 1853 school building was moved to make room for a bank building.

18

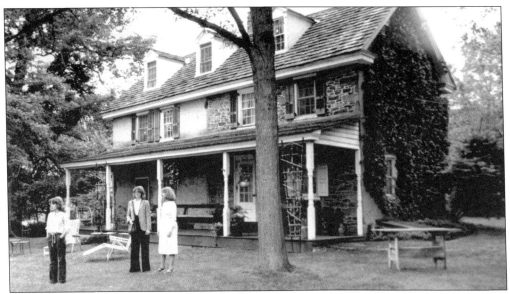

Shown here is Grindleton, named for the town in England. The original house was built in 1717 by the Welsh Quaker Humphry Humphry. The house had a large walk-in fireplace with a beehive oven. The second section of the house was added *c. 1734*. It has hand-hewn beaded rafters on the second and third floors. The framed section was replaced with stone after the second was built. Access to Grindelton was achieved through a ford across the Park Creek.

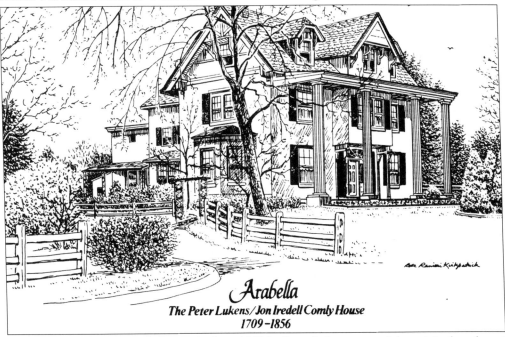

Arabella
The Peter Lukens/Jon Iredell Comly House
1709–1856

The earliest section of Arabella was built in 1709 by Peter Lukens, one of the original settlers of Horsham. The two-room stone building, one of the very first structures in Horsham, is the rear entranceway to the present-day house. Lukens was the brother of Jan Lukens, another of the original settlers of Horsham. The brothers appear to have come from Holland to Philadelphia in 1688. Peter Lukens settled the property in 1709.

The last farm in Horsham on the western end of Limekiln Pike is where Ulysses S. Grant's mother grew up. The Simpsons purchased 164 acres in 1763 and expanded a log cabin on the property. Hannah Simpson married Jesse Grant. Shortly afterward, in 1820, the Grants moved to Ohio. There, they had six children, one of whom was Ulysses Simpson Grant. The Worth family bought the Horsham farm in 1904.

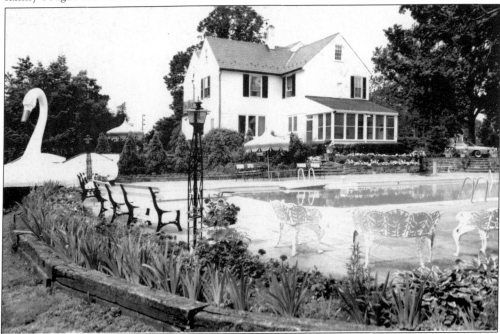

In 1790, upon his marriage to Alice Conrad, John Jarrett II built a two-story house. That house forms the front of the present house at 1300 Easton Road, directly across from the naval air base. The current owner of the estate once owned the Willow Grove Amusement Park—hence, the swan boat, formerly a popular ride on the lake in front of the park's music pavilion.

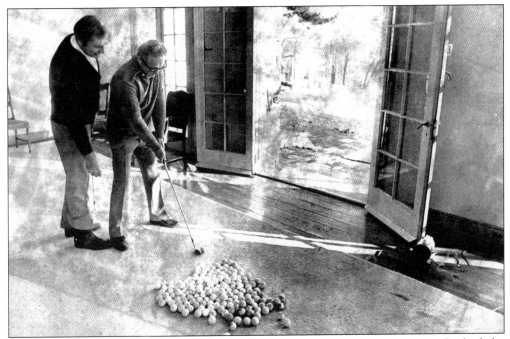

Max Hankin was an avid golfer. As the owner of Hidden Springs Golf Course, he had the opportunity to play as often as he wished. He still felt the need to practice by driving balls out of the door of his home on Easton Road into the nearby field.

The Hidden Springs Golf Course was the site of many golf tournaments. At one point Max Hankin convinced Perry Como, center, and his musical group to pay a visit. With their daughter Minna, Janet and Max Hankin stand to the right of Como.

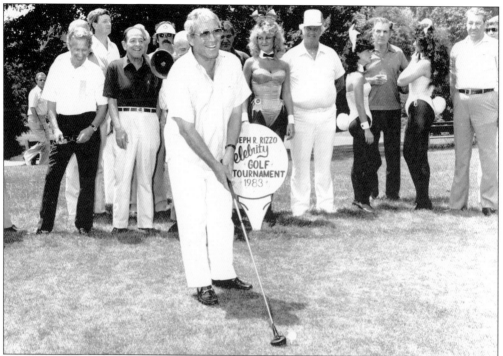

The Hidden Springs golf tournaments were well known in the area. The course was a stop on the Ladies Professional Golf Association tour in the 1970s and 1980s. In addition, the course was the scene for many pro-am celebrity tournaments, with Max Hankin, left, raising money for local charitable purposes. Shown with Hankin are Perry Como, teeing off, other golfers, and three Playboy bunnies.

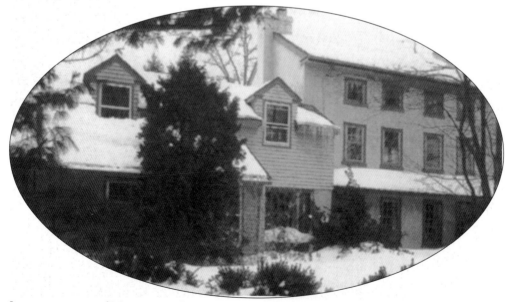

In a recent issue of *Montgomery County Town and Country* magazine, the 1777 Holst Farm was mentioned: "Obscured from the main road, this centuries-old farmhouse, completely surrounded by new home developments, stands as a reminder of what this land used to be."

Two

RELIGION

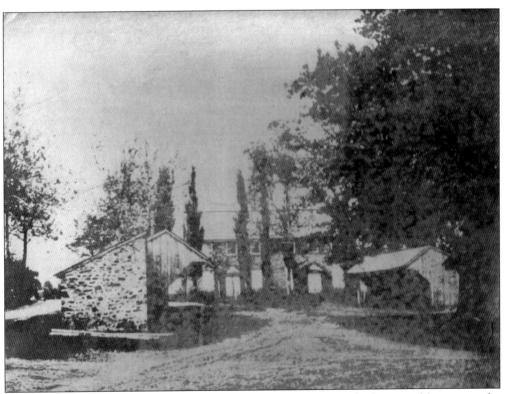

In 1860, the Friends meetinghouse needed many horse stalls, as the horse and buggy was the dominant form of transportation. The earliest photographs show several sheds, one of which still exists, and the meetinghouse with no porch. Here, Easton Road is on the left.

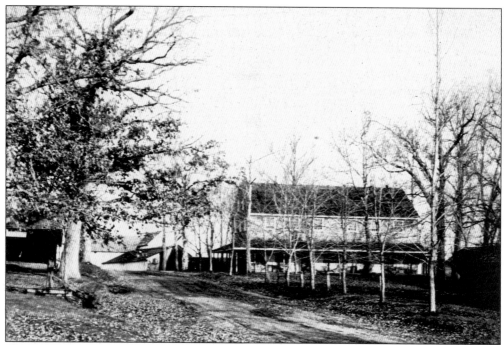

In the 1880s, the Friends meetinghouse lost its shed near Easton Road, and the present-day porch was added. The earliest roads were frequently built to make travel from one Quaker meeting to another more convenient. Norristown, Byberry, and Meetinghouse Roads were examples of this.

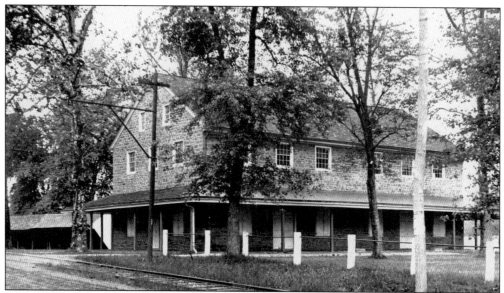

By 1900, the members of Horsham Friends Meeting could use the trolley line from Willow Grove to Doylestown to attend First Day services. However, since they were still farming, most members arrived in a horse and wagon. The 1739 Quaker school was located across Easton Road from the meetinghouse. Automobiles were not available yet.

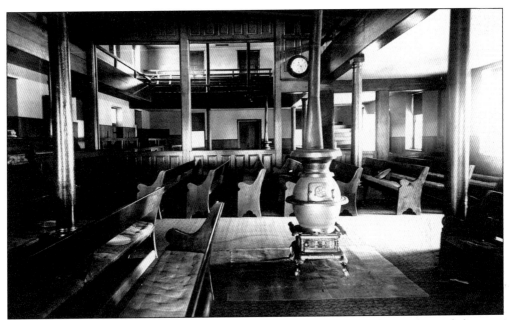

The interior of the Horsham Friends meetinghouse here is virtually unchanged from its construction in 1803. In the early history of the meeting, women met on one side of the partition and men on the other. A moveable partition was built so that a joint meeting could be held. The partition can still be hand-cranked up and down; however, the meeting has not been segregated since the late 1800s. The heating was rudimentary, as shown by the potbelly stove located in one of the side rooms off the main room.

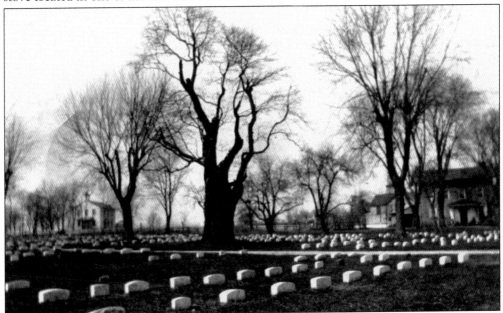

Almost every Friends meeting had a private cemetery for the members. This one, located across Easton Road from the meetinghouse, shows the simple headstones of the times. The first grave was for Peter Davis, who died in 1719. In the back, the 1739 schoolhouse and the original Quaker farmhouse are still in use.

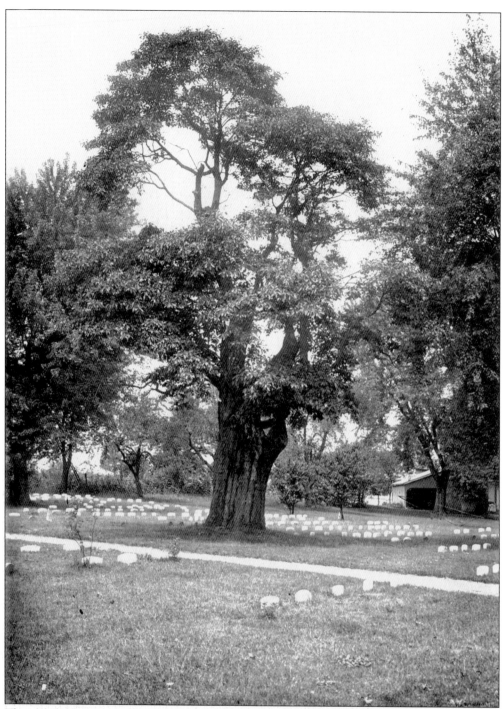

The sassafras tree in the middle of the Quaker cemetery was reported, in 1917, to be the largest and oldest known tree of its species in America. It measured 16 feet in circumference at the base and was several hundred years old, having been there when the cemetery was founded in 1719. This tree was struck by lightening in 1942 and never recovered. In 1996, children set the stump on fire.

St. Matthew's Episcopal Church was started in 1968 and was housed in the Union Meeting Hall, in Prospectville. A church on Tennis Avenue was completed in 1972. With a growing congregation, now numbering 700, more buildings were added in 1981 and 1997.

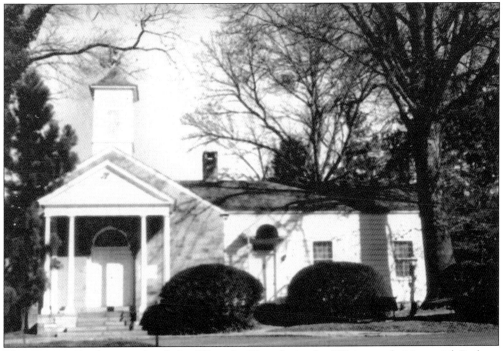

This is a 1931 photograph of the Wayside Church in the Whitemarsh Memorial Park at Horsham Road and Limekiln Pike. This chapel has been preserved and is still used for weddings, social affairs, and, of course, funeral and memorial services.

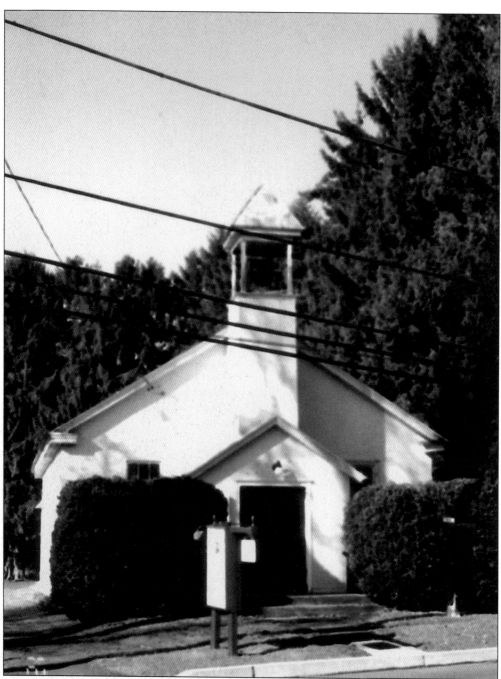

The Prospectville Community Hall was erected *c.* 1870 on land owned by George Worth of Horsham. George Fry was employed at $2 per day to build the hall. Displayed on the wall were these rules: (1) "No initials to be carved on the benches" and (2) "No spitting on the floor." Today, the hall is organized under a state charter and operated by a board of trustees. It continues to serve as a place of worship for various denominations.

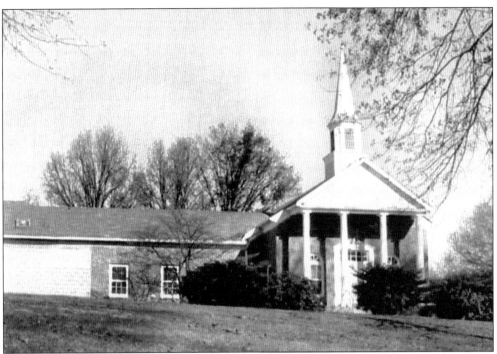

In 1885, Sunday school was held at the community hall by the Methodists. By 1889, religious services were held on a regular basis and a small library was located in the back of the building. In 1955, the present building was built on Horsham Road.

The Orthodox Friends Meetinghouse was built on Dresher Road at Sawmill Road near the existing 1803 meetinghouse when, in 1827, there was a division among the Quakers across the country. It was only in use for a few years before being abandoned and becoming a residence.

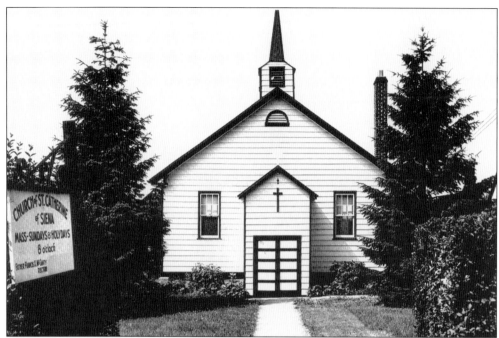

The St. Catherine of Sienna Church is situated on property contained in the original charter of King Charles II to William Penn. The first proprietor was Joseph Fisher, a native of Cheshire, England, who lived in Ireland at the time he purchased the property. In 1685, he surveyed and purchased over 5,000 acres of land in what is now Horsham Township.

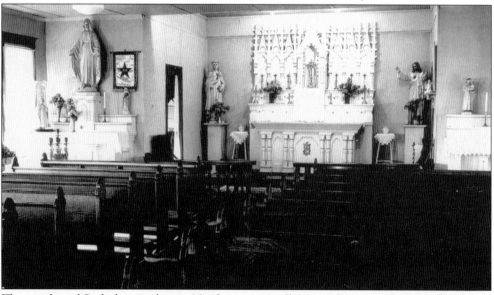

The number of Catholics residing in Horsham was small. Most of the township's residents were either descendants of the original Quaker settlers or Protestants who moved from Philadelphia's Germantown. In fact, there was a distinct anti-Catholic sentiment in the area during the late 1920s and early 1930s. However, more Catholics began to settle near the hamlet of Horshamville, and the St. Catherine of Sienna Church was built to solve their need for a place of worship. This is the interior of the church.

Three

MILLS, INNS, AND FARMS

The Golden Ball Tavern was located at the intersection of Governor and Privet Roads. The building was erected in 1787, although there are references to the Golden Ball Inn and an earlier tavern existing at this location and to Sir William Keith's acquaintances staying at the tavern during his governorship. The Golden Ball was a tavern and assembly hall until 1857. Thereafter, it was used as a private residence. The building was demolished to make way for the Willow Grove Naval Air Station.

Davis Grove was at the intersection of Privet and Governor Roads, where the naval air station is now. Hannah Davis Saunders is shown on horseback in front of her barn in Davis Grove. The house is visible in the distance behind the horse and carriage. The Golden Ball Inn was across the street.

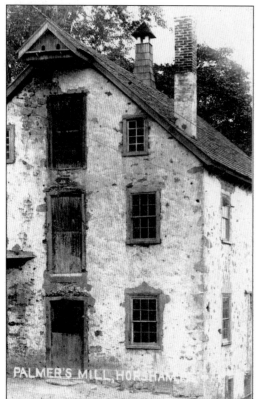

Palmer Mill, as it is known today, was built by William Lukens shortly after 1740. The local gristmills were feed and flour mills until c. 1880. At that time, the patent process roller mills became popular for the grinding of mill flour. Frank Palmer added a pork-packing department. Palmer Mill was still operating in the 1920s. The mill building is still standing near the intersection of Dresher and Horsham Roads.

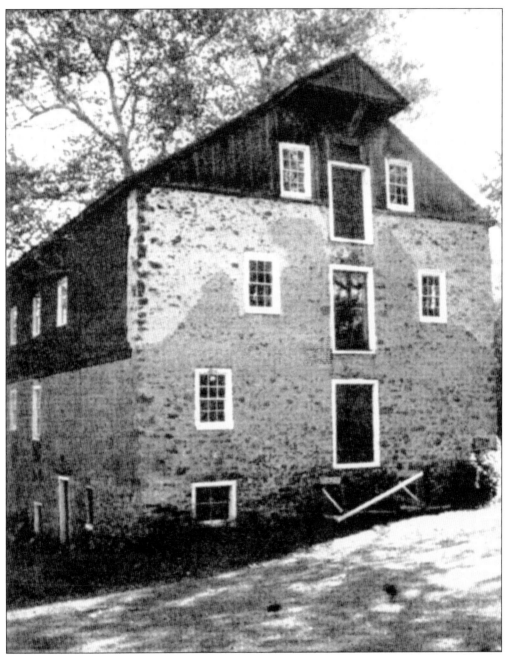

Located at the intersection of Keith Valley and Davis Grove Roads, the Kenderdine Mill is the only surviving mill in Horsham Township. The mill dates back to 1735, when it was built by Joseph Kenderdine. The site actually combines four buildings: the mill building, the owner's house, the carriage house, and the stable. The mill was powered by water, a millrace that ran an interior waterwheel. The water came from a tributary of Park Creek. Today, it needs only the waterwheel and belts to be operational. The mill remained a working mill until the early 20th century.

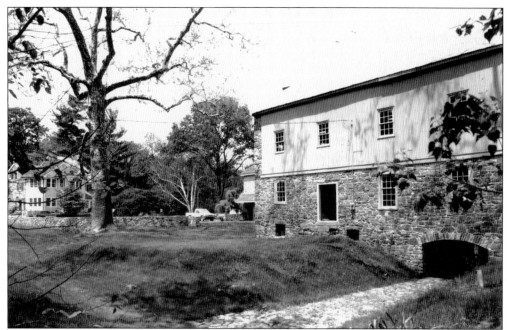

The exterior of the Kenderdine Mill is shown built over the raceway that brought the water into the mill to turn the waterwheel. The iron waterwheel was the breast-shot type: the water passed under the wheel. The wheel was nine feet wide and nine feet tall. It was given to the U.S. government during World War II.

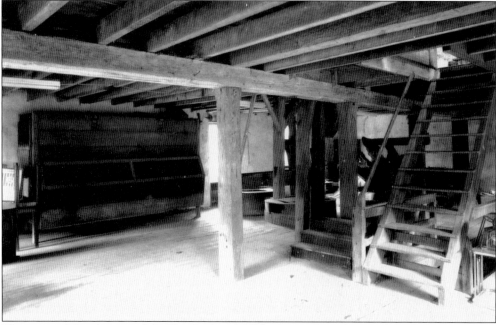

This view of the interior of the Kenderdine Mill looks southward toward the bolting (sifting) machine on the second floor. It is rare that this type of equipment remains in an old mill. The form of construction used here is the post-and-peg method. No nails or bolts were used in the construction of the mill.

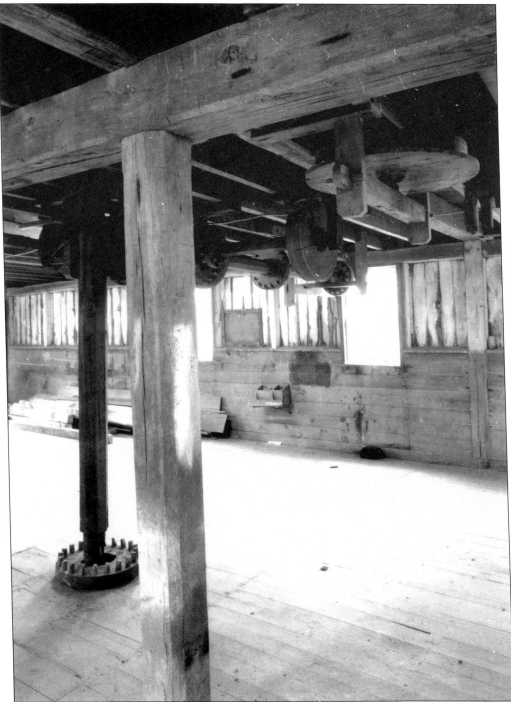

Inside the Kenderdine Mill, the wooden cogs and shafts remain. The power shaft, used to run the internal elevators, passed the grain to the third floor. The grain dropped down to the milling and sifting areas to be ground into flour. The equipment was used to sift and bag the ground flour.

Jarrett was a familiar name in the Horsham Township area. David Jarrett, shown here, was born in 1821 and was the owner of the Jarrett farm at Meetinghouse and County Line Roads. He died in 1913. Shortly thereafter, his farm was sold for housing.

The original home was located across Keith Valley Road from the mill. The road was built after Robert Shay took over the mill from Joseph Kenderdine. This building is owned by the Commonwealth Country Club.

Limekiln Pike, once named Whitehall Turnpike, is one of the oldest highways that passed through Horsham Township. These highways were used to transport natural products between the countryside and the markets in Philadelphia. Owners of property alongside the highways pooled their resources to maintain the roads. The pike had a wooden gate to block the highway. A lone rider paid 2¢, and a carriage or a four-horse rig hauling hay paid 10¢.

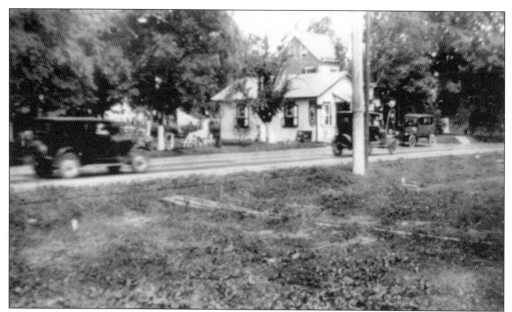

Hockle Beer Garden is shown c. 1933, before being demolished and replaced by the new and popular Otto's restaurant.

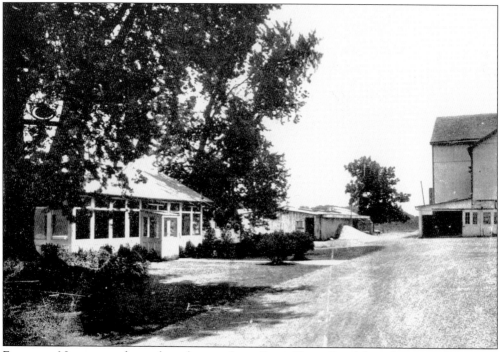

Evergreen Nursery was located on the way down Davis Grove Road from Prospectville toward Kenderdine Mill. The office was on the left of the driveway. Across from the office was a two-story multibay garage with an L-shaped bungalow, whose walls were made of old doors. The bungalow served as lodging for summer guests. It had six bedrooms with a common room. Activities suitable to gentlemen of the period, such as skeet shooting, hunting, and horseback riding, were available.

PARK VALLEY FARMS
—and—
EVERGREEN NURSERIES

PROSPECTVILLE :·: PENNSYLVANIA

The Hill Nursery, on Davis Grove Road, was sold to Arthur Kunz and his sister Dorothea in 1937. It became known as Park Valley Farms and Evergreen Nurseries. In the late 1930s, it was probably the largest East Coast grower of azaleas. A large tin sign cut to look like a tree was near the entrance. The sign was about 10 feet high. Visitors were always welcome and could buy direct. Delivery was free for anyone within 20 miles. Anything farther away was delivered to the Railway Express Station in Ambler. Times were hard, and Dorothea Kunz married Ralph Morse, the last male descendent of the inventor of Morse code. Morse paid off the nursery debt and became the owner of Park Valley Nurseries in 1942.

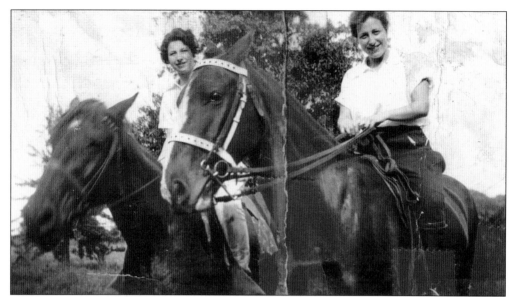

Two of the Kunz daughters, Esther and Charlotte, enjoy riding on the family farm, soon to be combined with the Hill Nursery for a farm and nursery of over 160 acres.

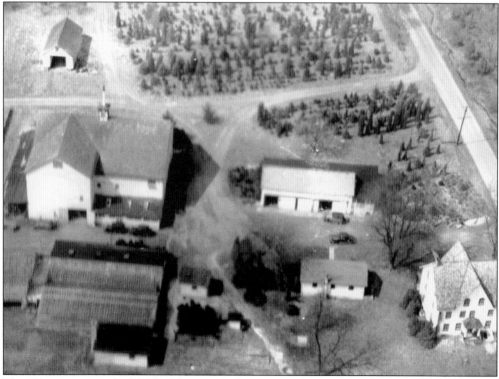

This 50-acre nursery had 12 buildings including a pump house, greenhouses, a skeet shooting shed, a potting shed, garages with guest bungalows, a barn, a corncrib, a duck shed, a horse shed, a springhouse, and a main house. A hurricane in the late 1930s demolished the silo, which was never rebuilt because the nursery had little need for a silo. A sign on the barn roof, visible to planes flying from Pitcairn Field, read, "PARK VALLEY NURSERY."

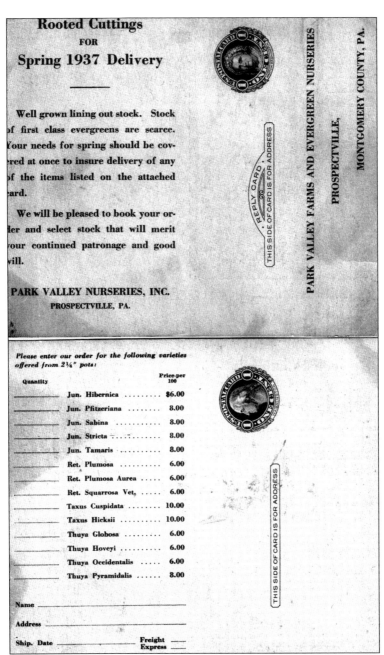

In the good old days, a postcard cost a penny. In 1937, Park Valley Nursery made use of direct-mail marketing to its customers. The nursery used a postcard with an order form on an attached return card. The total marketing cost was 2¢. Offered then were a series of evergreens priced between $6 and $10 per 100 plants. In the 1950s, Horsham created a park and recreation board. The board purchased 30 acres of the Park Valley Nursery. Most of the nursery acreage is now Horsham Township's Deep Meadow Park. The park's walking trail goes through the area where nursery evergreens were raised. Early projects included a skating area, picnic tables, grills, a hand-operated water pump, toilet facilities, and a shelter. Footbridges were built over the creek, and the present system of Horsham Parks began.

When Charles Carr opened a new store in Hallowell, the post office was moved from its Davis Grove location. It is unclear when the Davis Grove post office was discontinued, but it is found on the map as late as 1877. The Carr store was at Easton and Moreland Roads. The Hallowell post office was in Shanken's store until 1954. In 1958, the post office was absorbed by the Horsham post office. The building still exists. Today, it is a sandwich shop.

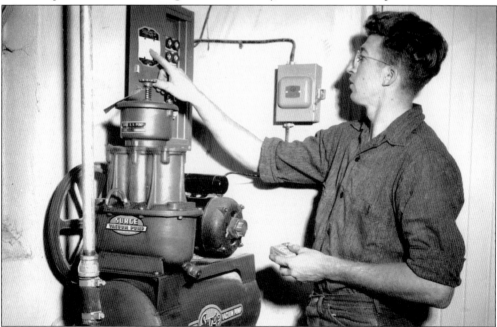

Horsham was a farming community through the 1960s. Farmers had to keep up with the latest laborsaving devices. Here, in 1948, Morris Jarrett has just hooked up his new milking machine. Jarrett's farm, on Horsham Road adjacent to the 1859 Babylon School, later became the new Hatboro-Horsham High School.

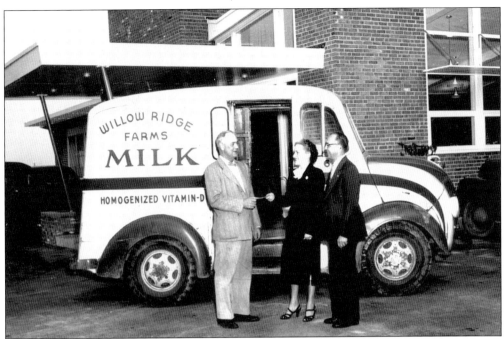

Willow Ridge Farm was located where a large industrial park exists now. The dairy produced, processed, and delivered milk products in its own trucks. The new truck is shown being accepted by Lawrence Linquist at the site of the ice-cream store. Williamson's restaurant has replaced the ice-cream store.

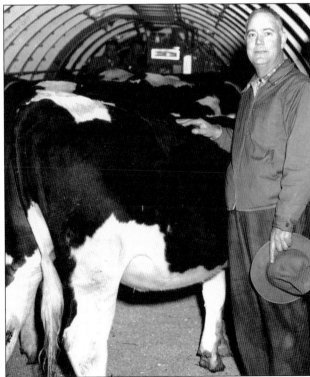

Lawrence Linquist was involved in helping to improve dairy stock in South America. Cows were shipped by air in C-30 transports flying out of the air base in the early 1950s.

Max Hankin is preparing to start his old Oliver tractor, which had been used on the farm since the 1920s. The Hankin farm, across from the entrance to the air base, was the largest producer of sweet corn in the East. It became an approved supplier to the armed forces during World War II.

Four

THE TOWNSHIP

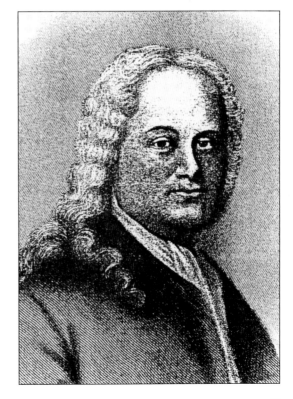

Samuel Carpenter of Sussex, England, purchased 5,000 acres of the new land given to William Penn by the King of England for a debt owed to his father. The land was surveyed by Thomas Holmes, and the area Carpenter bought was named after his home in Horsham, England. Carpenter was one of the four original purchasers of land in Horsham.

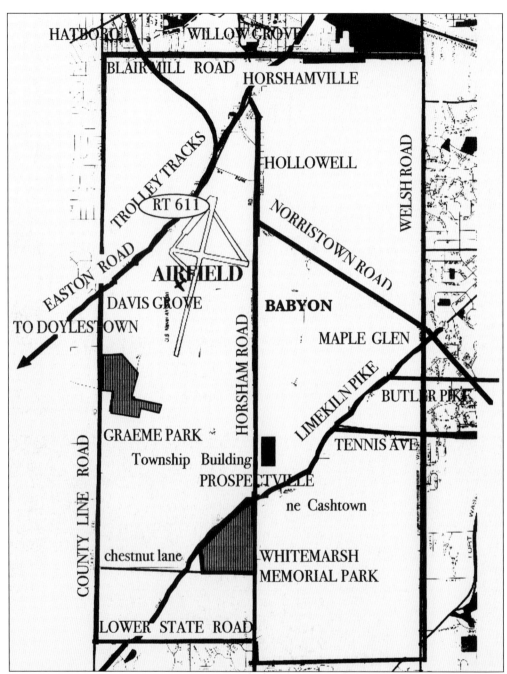

A simplified township map depicts the main roads and outstanding landmarks. It names the original towns within Horsham Township. The first traffic light in Montgomery County was at Horsham Road and Limekiln Pike. Limekiln Pike had been a turnpike and was heavily traveled. Horsham Road was the second most important road. Both roads were the basis of the growth of the township. The airfield is clearly the most dominate feature of the community.

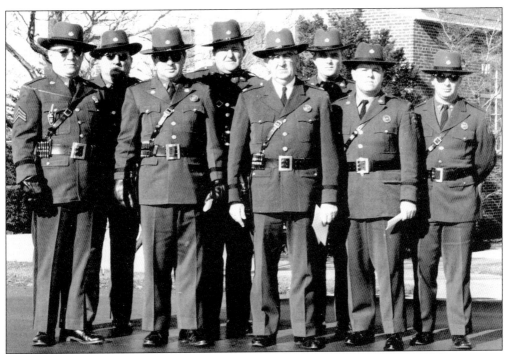

The Horsham Police Department was created in May 1951, when the board of supervisors deemed it necessary to provide for the safety and security of the residents of Horsham Township. The department began with one man who was appointed the chief of police—George W. Freas Sr. Later that same year, a second man, Benjamin P. Samson, was appointed to serve with the chief. Shown is the department in the late 1950s.

Succeeding Chief George W. Freas was Chief John L. Donovan, third from the left. He is shown here with Lieutenant DelSoldo, Robert Ruxton, and Joseph Repkoe.

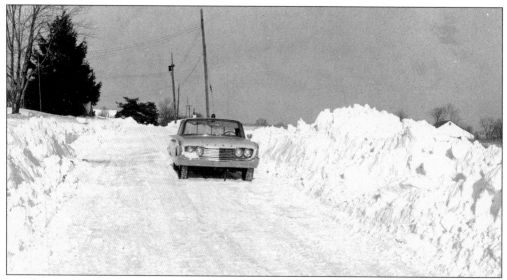

A police car is patrolling after a snow storm. Beginning in 1951 with one patrol car, the police department increased its fleet of vehicles. By 1976, the department had three motor vehicles and two helicopters. There were five patrol cars, three detective cars, two administrative cars, one mobile crime laboratory, and one surveillance van. All patrol cars were equipped with oxygen and lifesaving equipment.

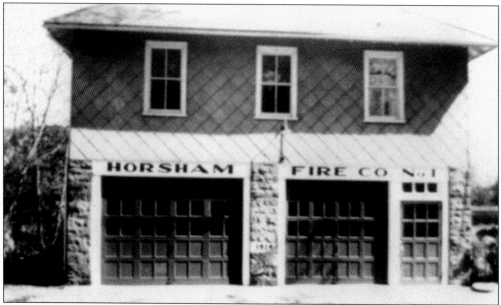

In 1913, the barn of the of the Horsham Friends Meeting burned down. Due to the damage caused by the fire, the local people began to speak of the need for a fire company. Leroy Forker was in the town general store, which had been run by Oliver P. Smith and then by the Freas family, when the topic of organizing a fire company was causing much debate. Benjamin Parke held that neither Forker nor he would ever see such an organization in the community during their lifetime. Forker, holding the opposite opinion, set out on the day's deliveries. At each stop the idea was discussed and interest grew. Finally, at the home of Jay Magargee, Forker was given $10 toward the cause. That was the first donation for the Horsham Fire Company.

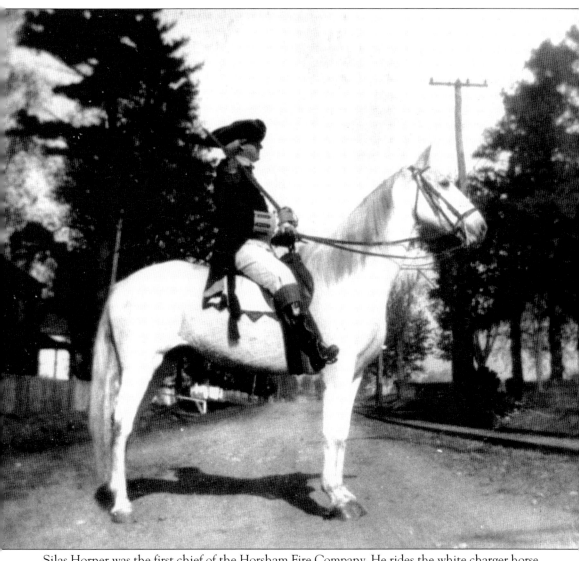

Silas Horner was the first chief of the Horsham Fire Company. He rides the white charger horse at Easton and Meetinghouse Roads, shown here with the trolley tracks. The fire company had only horse-drawn equipment.

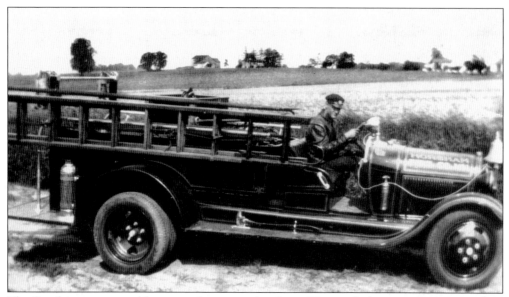

The fire department used horses and a wagon for about 10 years before switching to gasoline engine trucks. One of the trucks was a 1929 Model A, which had a chemical tank mounted on it. It was later converted to a pumper. The second Horsham fire truck was a 1924 Reo pumper, shown here at a fire in Hatboro.

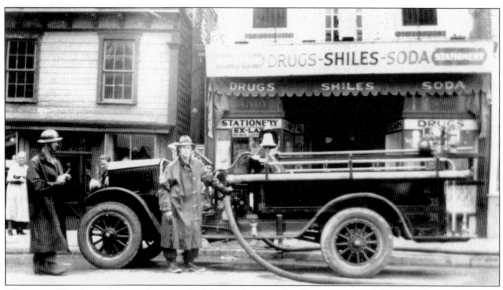

The next Horsham fire truck was a 1924 Reo. It cost the fire company $8,000. This picture was taken in Hatboro. The various fire companies responded to each other's alarms.

Norman and Wesley Ahn, both assistant fire chiefs, pose with the 1929 Model A fire truck. The Ahn twins were involved with the Horsham Fire Company all their lives.

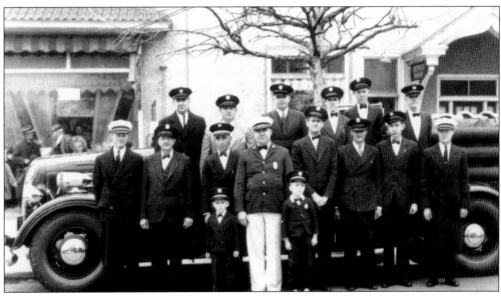

Firefighters pose with the new 1938 Hahn fire truck. From left to right are the following: (first row) Norman Ahn, Ben Kohn, Herb Camp, little Joe Camp, Robert Freas, little George Freas, Ed Miller, Paul Hendriccks, Pete Craig, and Wesley Ahn; (second row) George Freas, William Fitzgerald, Frank Schwartz, Todd Miller, Jack Dil, and Carl Hoffman.

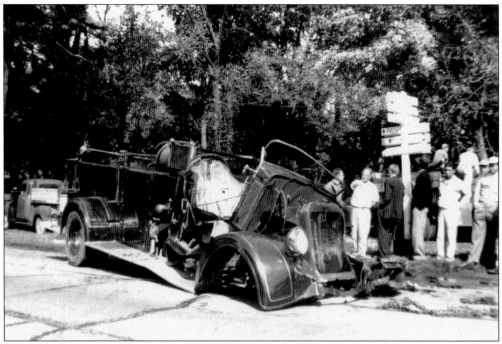

Pictured here is the Horsham chemical truck after an accident at Welsh Road and Butler Pike in October 1951. The wreck was caused by two fire trucks colliding after responding to the same fire. Both came to the intersection at the same time. The Fort Washington fire truck hit the Horsham truck as the two entered the intersection. Later, the Fort Washington truck driver was found negligent for not stopping before entering the intersection.

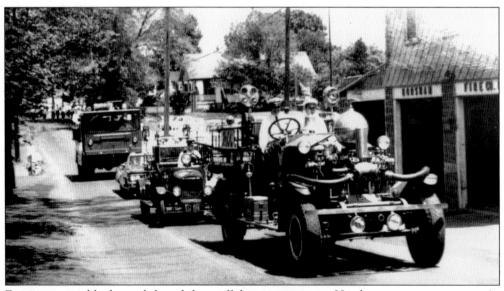

Fire companies liked to polish and show off their equipment—Horsham was no exception. As shown here, Fire Company No. 1 was preparing for the annual Jenkintown parade.

Five

TROLLEYS

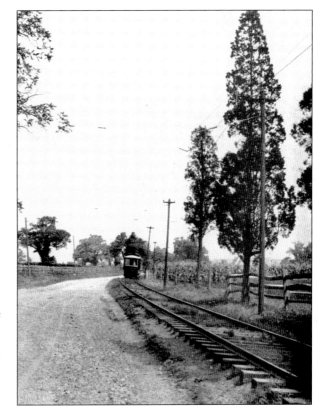

This view is looking north on Easton Road, the route from Doylestown to Willow Grove. The vehicular roadway is unpaved, but a ribbon of steel runs alongside it. The transit company's car No. 689 is on its way to Doylestown just after the erection of catenary wire on the line in 1898.

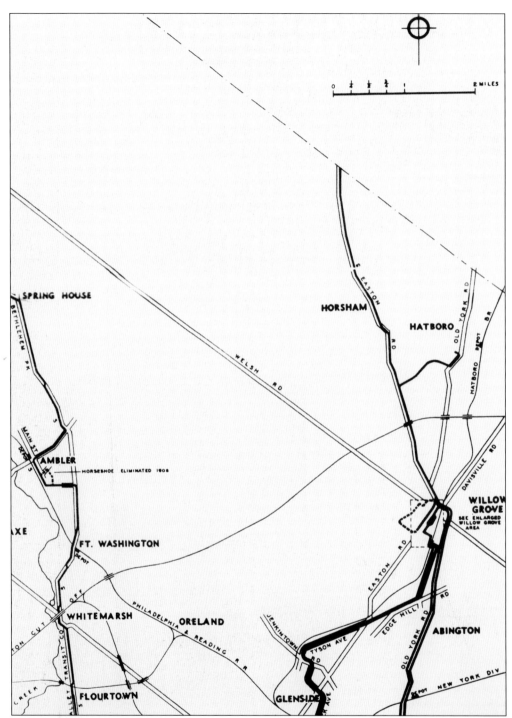

A map of the trolley tracks that ran through Horsham is shown here. The rail line started in Doylestown, made a spur to Hatboro, and continued on to Willow Grove, where it connected to the trolley cars that served Philadelphia. The line lasted from 1895 to 1931, when it was replaced with a bus line.

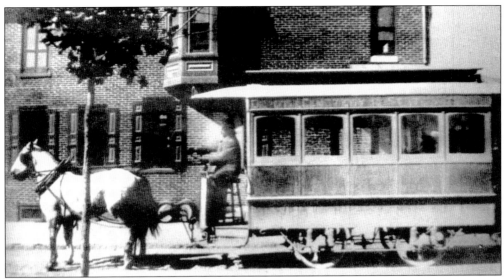

Originally, the town's trolleys were pulled by horses. The Doylestown line was established in September 1894. It was not until May 1898 that the catenary electric line was strung throughout the length of the tracks and the electric cars began operation.

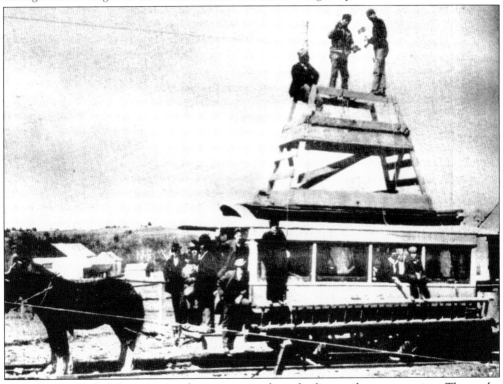

Three horses hauled this car over the country roads to the line under construction. There, the car was then placed on the newly laid tracks. The raised framework, applied over the roof of the car, enabled workers to reach the wires. The wire was unreeled from a huge drum, permitting reasonably fast work. It was not uncommon for workers to string two or three miles during the short hours of a winter's day.

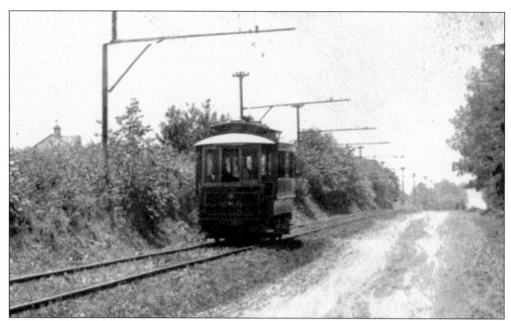

In good weather this was a pleasant trip. Between 1897 and 1898, the Buck County Railroad Company built a power plant and a barn at Paul Valley along the little Neshaminy Creek. Two Sterling boilers provided steam to run the electric dynamos. The trolley voltage was 500 volts DC. The first electrified trolley cars started the run from Doylestown to Willow Grove on May 24, 1898.

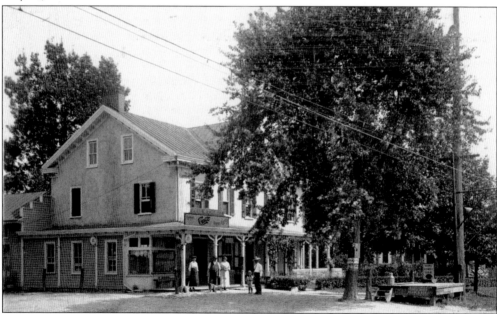

Hallowell's station and the platform in front of Wes Freas's store is shown, located at the corner of Meetinghouse and Easton Roads. Local farmers placed their milk cans on the platform by 7:30 a.m. each day. The trolley came along shortly thereafter and took the milk to be sold in Philadelphia. Each can was marked with a label showing the name of the owner, and the next day, the cans were returned to the same platform.

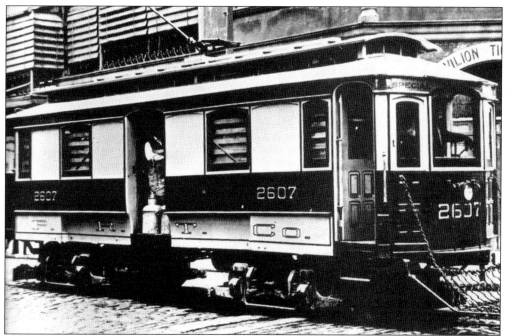

The Prospect Creamery delivered 2,800 pounds of butter per week and 9,000 pounds of milk per day to market . The trolley cars in 1889 became the rapid transit to Doylestown and Willow Grove and to Philadelphia on the Easton Road.

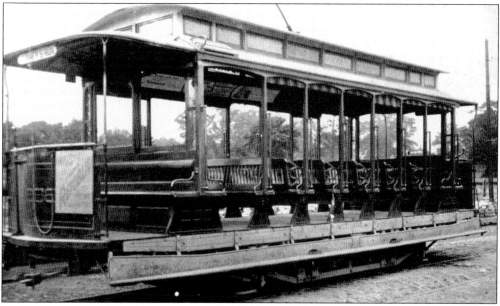

Open cars were used until 1898. The St. Louis car was painted maroon and white, with black-edged silver lettering. The body, seating 24 passengers, was 20 feet long. The car was 29 feet overall and 7 feet 9 inches wide. The old Doylestown cars, now part of the Philadelphia Rapid Transit Company (PRT) fleet, were repainted in company colors and renumbered 83 to 87 and 90 to 92. The three Jackson and Sharp nine-bench open cars, numbered 8, 9, and 10, were renumbered 516, 520, and 523.

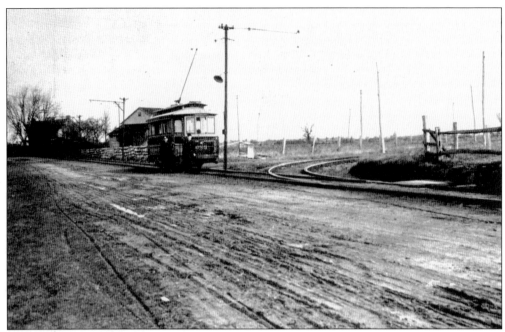

This 1898 Philadelphia Traction Company car is viewed from an old cable car with a Bemis truck. This car was being used as an electrical test car when this picture was taken in 1909. This view is from Hatboro Junction, looking north. Doylestown is straight ahead. Hatboro is to the right around the curve.

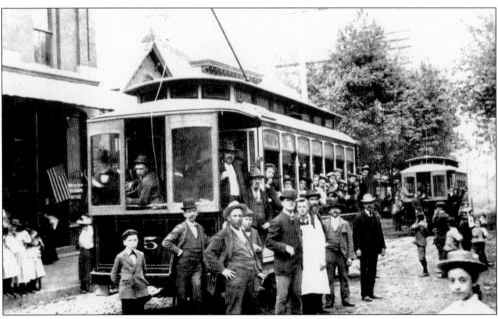

Here are cars No. 5 and No. 6 of the St. Louis Car Company. They were later renumbered as part of the Philadelphia Traction Company 80 series. The Doylestown terminal is pictured on the first day of the cars' operation in Doylestown, May 26, 1898.

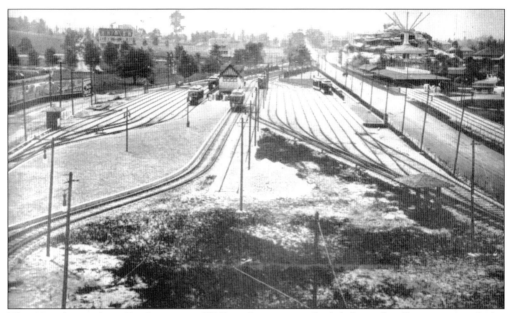

The 12-mile run from Doylestown to Willow Grove was scheduled to take 45 minutes, with the possibility of making it in 40. A construction car and a sprinkler completed the roster, but three open cars were leased from the Frankford, Tacony, and Holmesburg Street Railway Company to handle the summer crowds. The line proved popular beyond the expectations of the promoters, and on one Fourth of July, a car carried a record-breaking 108 passengers. This view was taken from Willow Grove Park in 1905.

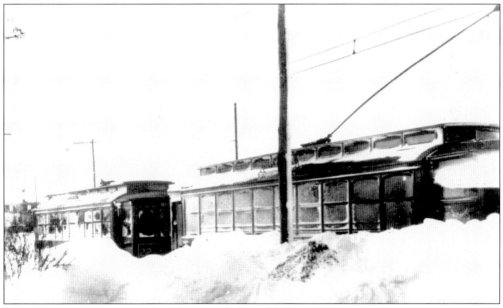

This February 1914 view shows the snowdrifts at Hallowell's Junction. It was necessary to dig out most of the line by hand after this storm. The snow in Horsham Township was noted as blizzard level many times, and since the economy depended on the milk trolley, it was often necessary to keep the trolley running.

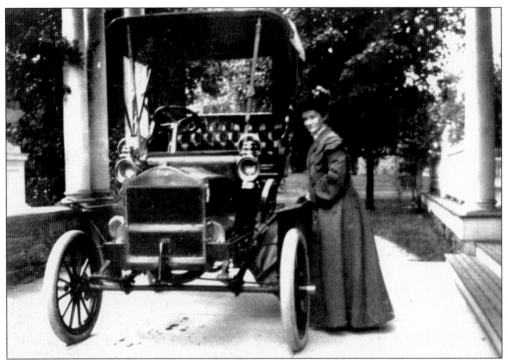

The majority of the passenger service on the trolley disappeared with the advent of the private passenger vehicle. No longer were people tied to the trolley line, which cut through only the corner of the township. With a car they could roam over the entire area, and if they wanted, they could go to Philadelphia whenever they pleased. The trolley was discontinued, and the Works Progress Administration removed the tracks in 1931.

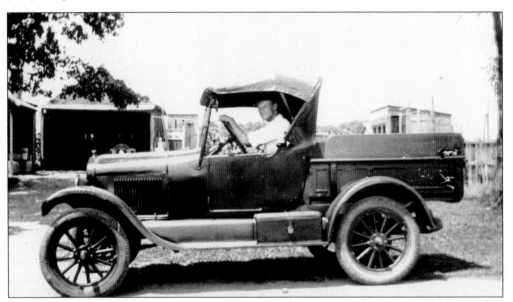

The days of the trolley car were numbered. This Ford Model T pickup truck, which cost $75 in 1925, helped to do away with the milk trolley and the freight trolley. This truck was owned by Norman Ahn.

Six

SCHOOLS

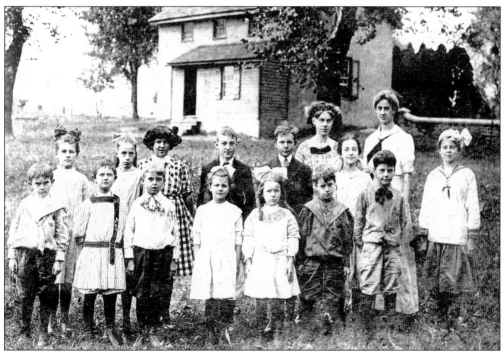

The first school in Horsham Township was the Horsham Friends School. The original deed, dated March 27, 1719, from Hannah Carpenter, allocated 50 acres to the members of Horsham Friends Meeting to be used for a meetinghouse, a schoolhouse, and a burial ground. The year 1739 is found inscribed on one of the school building's stone walls now standing on the meeting grounds at Easton and Norristown Roads. It was the custom of the Friends to provide education for their children. From left to right are the following: (first row) John Williams, Sara Hallyer, Franklin Hormer, Mary Park, Mary Thompson, William Hallowell, and Joseph Penrose; (second row) Helen Thompson, Gainor Jarrett, Helen Zeigler, ? Satterthwaite, Dethwell Parr, Marian Warner, and Miriam Stackhouse.

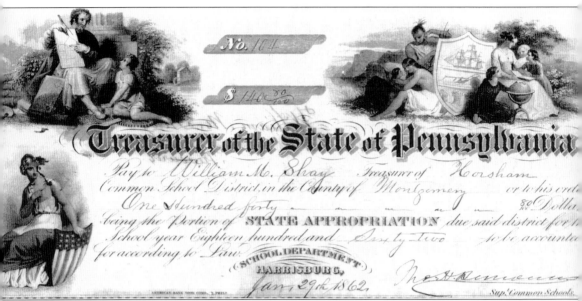

This Pennsylvania reimbursement check, dated January 29, 1862, is made out to the treasurer of Horsham Common School District, William M. Shay, for the amount of $140.80. At the time, one teacher taught four grades. At the each of the four schools there were two teachers for eight grades. The schools were open to all and were considered common or public schools. Tuition was not free, and at the time of the founding of the school, it was fixed by law at 3¢ per day. In addition to the common school, private schools were held in the homes of various members of the meeting. Three prominent Friends—John Lukens, surveyor general of Pennsylvania; Abraham Lukens; and Benjamin Cadwallader—were overseers of the Friends School. In 1855, a new stove costing $14.14 was installed in the school.

HORSHAM TO VOTE ON SCHOOL LOAN

An Increase of Indebtedness of $65,000 Has Been Proposed

STATE MEN ARE COMING

A meeting of the Horsham School Board will be held Wednesday evening, October 14, at Horsham firemen's hall to explain the school problems. County Superintendent Kulp will speak. Dr. Haas, state superintendent of public schools, will send one of his able assistants, L. H. Dennis, who will explain to the people any school problems and will be able to give any information.

The school board of Horsham township will again put before the voters at the November election the question of whether or not Horsham shall increase its indebtedness by $65,000 to join with Warminster township and Hatboro in constructing and furnishing a high school.

The newspaper reports that the voters authorized a loan of $65,000 to finance the Hatboro High School in 1925.

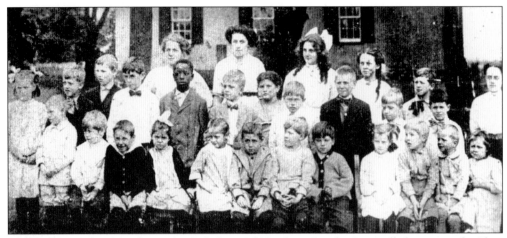

The Babylon School was located at Babylon and Horsham Roads. Originally known as the Shay School, it was the first public school in the township. It was replaced in 1804 on land donated by Joseph Nixon and his wife, whose farmhouse was at Privet and Horsham Roads. The 1804 school was replaced in 1858 with a new one-room schoolhouse. The children sat in the one room, with the smaller students in front and the larger ones in back.

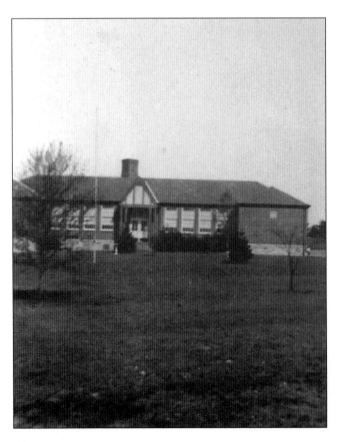

Dorothea Simons Elementary School was completed at Prospectville in 1933. The four old schoolhouses with coal stoves, water pumps, and outbuildings were deemed obsolete, and so were closed. Through the years students who lived in Horsham had the choice of attending high school in Ambler, Abington, Hatboro, North Penn, or Upper Moreland. The township paid the tuition, but students had to provide their own transportation.

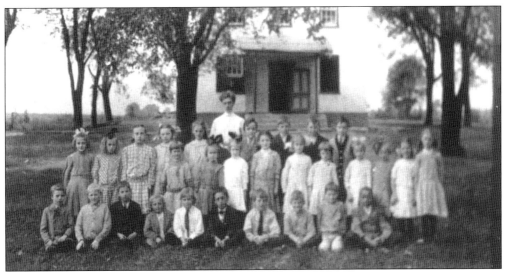

Usually, there were eight levels of grades, although schools were not officially graded in Horsham until 1890. Among the students pictured are Dot Hughes, Russell Tyson, Marion Conrad, Florence Potts, Ruth Weir, Emily Wildinger, Harold Weir and Clarence and Frank Rich.

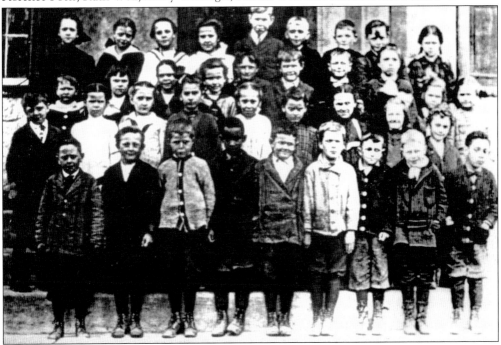

This large class of fifth- through eighth-graders was at the Horsham School. From left to right are the following: (first row) unidentified, Frank Rich, Walter Lefferts, George Nelson, Wilbur Burkardt, Leon Weir, Fred Buckholder, Charles Lefferts, and William Nelson; (second row) unidentified, Sarah Short, Eileen Wright, Lillian Craven, Freda Atkinson, Caroline Craven, Hannah Mann, Mayr Nash, and Ernest Williard; (third row) unidentified, Margaret Steever, Anna Steever, Jennie Harrah, Walter Buckholder, Irving Burkhardt, unidentified, Harold Weir, and Maury Craven; (fourth row) Edith Neely, unidentified, Edith Woodrow, Margaret Williard, Howard Short, Franklin Horner, John Myers, unidentified, and Verna Steever.

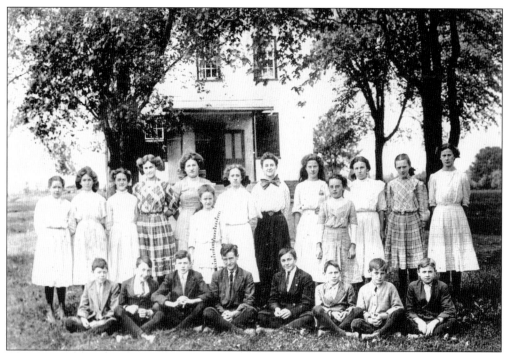

The Horsham School, built on Norristown Road near Homestead Avenue, was torn down after the Horsham Elementary School was built in 1927. Identified in the picture is John Whiteside, first row, second from the right. This school had a coal-burning stove.

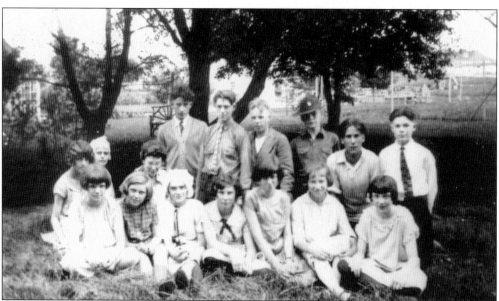

Pictured at the Horsham School prior to 1927, from left to right, are the following: (first row) Midge Fell, Martha Mann, Mary Burkhardt, Kathryn Shirk, unidentified, and Kathryn Monteith; (second row) Della Morris, Freda Louster, Maude Worstall, Gene Lenz, Warren Downs, Morrie Buckman, Carl Bergman, and Walter Woodroffe.

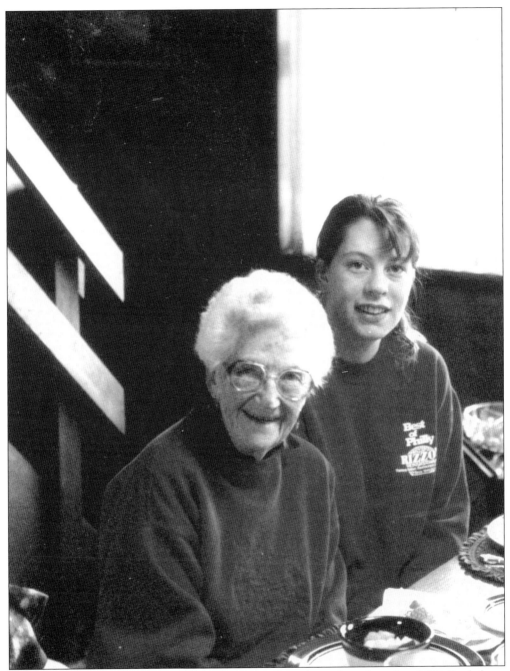

Mary Jones, the first grade teacher at Horsham School, used to drive her 1934 Ford down Limekiln Pike and pick up six or eight students, filling the coupe and its rumble seat. She became Mary Park at a Quaker wedding, with no minister officiating. She is pictured here with her granddaughter.

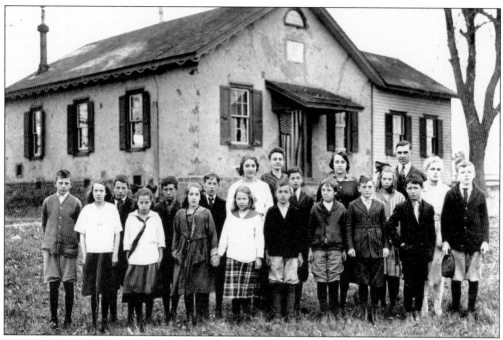

Prospectville School was one of the original three public one-room schoolhouses in the township. One of the boys in this late-1930s class is Harry Nesbitt. This school was torn down after the Dorothea Simmons School was built on Limekiln Pile in 1943.

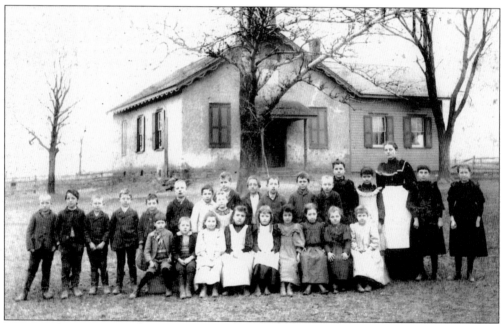

By 1842, the public school system had only partially been adopted. In summer, the teacher was paid 3¢ per day for each pupil whose parents could afford it. This was called pay school. During the winter months, there was no charge, as the tuition was paid by taxpayers' dollars. Usually there were eight levels, although schools were not officially graded in Horsham until 1890.

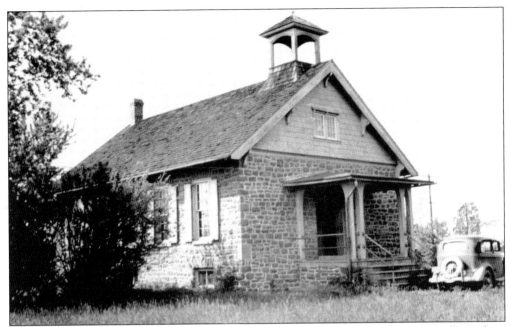

The Penblair (Elementary) School was built in 1909 on Schoolhouse and Cedar Hill Roads in an area known as Scrapple Hill. Wesley Mullin was the architect, George Zeitler, the builder, and Cy Hoffman, the mason. Charles S. Mann named the school, combining two Celtic words meaning "upland plain." The school was closed in April 1932 and was soon auctioned off. Dr. Walter and Mary Webb bought the school and converted it into a home. Some of their children and grandchildren still live in Horsham Township.

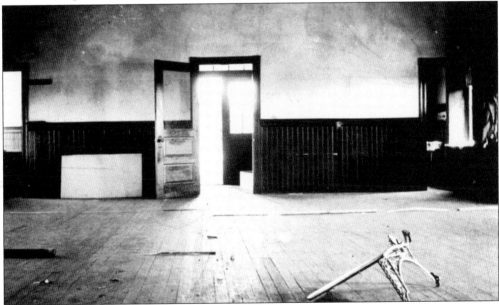

This photograph shows the interior of the two-room Penblair School, soon after the Webbs bought the place. The view was taken from the classroom, looking toward the cloakroom and the front doors. The girls' and boys' outhouses were located on the two back corners of the property.

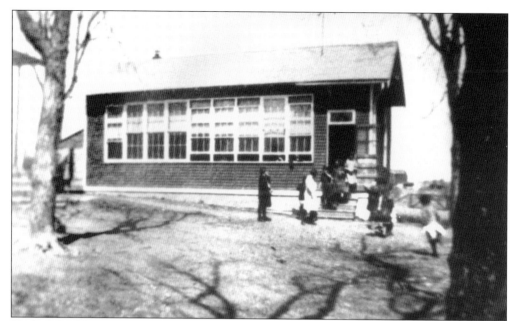

To the left of the new (1927) Horsham School is the old two-story school, which was to be torn down. In 1950, the Hatboro-Horsham school merger took place. Afterward, all students of high school age who wished to attend public school attended Hatboro-Horsham High School. In 1962, all elementary schools in Hatboro and Horsham were placed under one jurisdiction and the Hatboro-Horsham School District was formed.

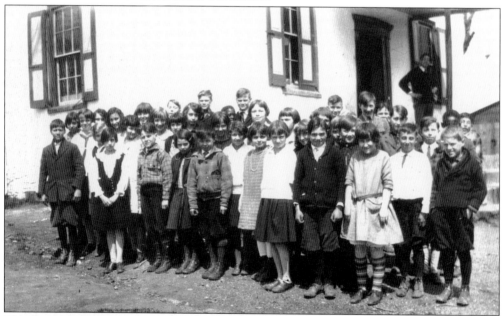

The Horsham School is shown here between 1924 and 1925, shortly before being replaced by a school with inside toilets and central heat. The Ahn twins, Norman and Wesley, appear in the back row. Among the other fifth- through eighth-grade students are John Smith, Mary and Jeanie Mann, Tim Ely, Dot and Elva Craven, Dan Comly, Wendell Rexinger, and George Yoder. Their teacher was Miss Ellis.

Seven

THE COLLEGE SETTLEMENT CAMP

The College Settlement Camp was purchased in 1922 to give children incentive through a wholesome, outdoor camping program. Currently, up to 20,000 children from the Delaware Valley use the camp each year. The summer camps are centered around providing a camping experience for those children who cannot afford a vacation. The camp includes 203 acres of land with 28 buildings, 3 campsites, nature areas, and overnight tent sites. Children arrived by trolley from Willow Grove or Horsham and, later, via a bus purchased by the camp.

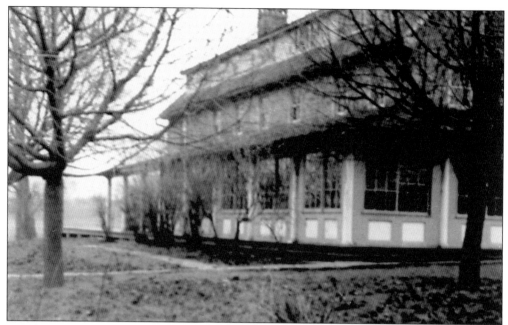

This house was owned by the MacGregors before they sold the 90-acre farm to the College Settlement in 1922. The house was reached via a driveway from Welsh Road. It was lived in by a tenant farmer who received $65 a month, plus a percentage of the produce sold from the farm.

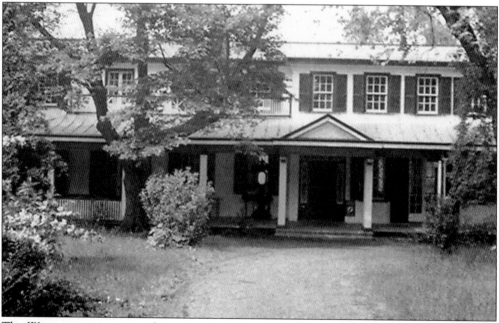

The Witmer estate mansion house is pictured in 1948. This was the main house of the large estate, 21 acres of which were purchased by the College Settlement in 1937 for $14,500. Included with the main house was a duplex on Witmer Road, a carriage house, a caretaker's cottage, and several greenhouses. The other portion of the property became the housing development known as Hidden Meadows.

The MacGregor-Ferguson House was damaged in a 1977 storm. Standing outside are executive director Leonard Ferguson, right, and his future replacement Frank Gerome. Ferguson was appointed by the board of trustees and moved into the farmhouse. He retired in 1982. The house is now named after him.

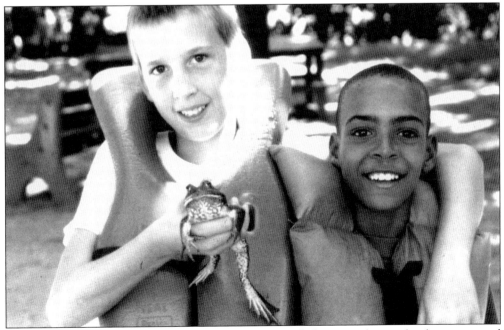

Photographed here are three pals. The two boys and their pet frog make for some good camaraderie during their stay at the camp.

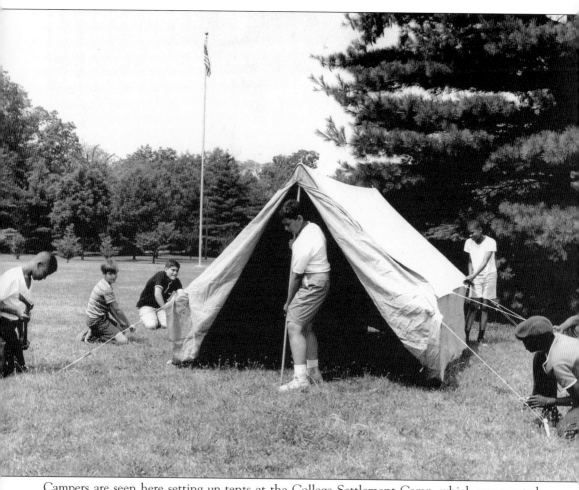

Campers are seen here setting up tents at the College Settlement Camp, which was created for underprivileged children from the city. At the time of this photograph, the camp had just expanded after the purchase of the Witmer estate and America was about to enter World War II.

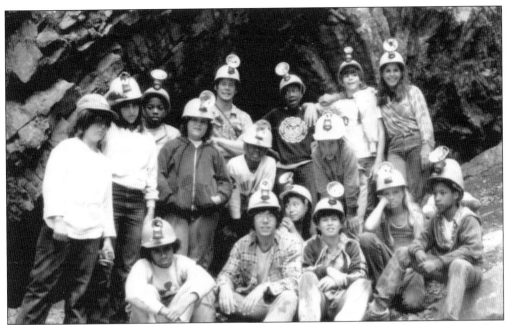

Campers try their hand at cave exploration. Note the helmets on all of the campers as they explore the caves. Exploring was typical of the variety of activities available at the camp.

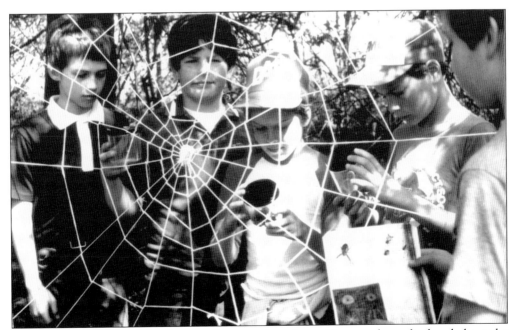

Spiderwebs are a part of the forest and many other places. Campers learn firsthand about the locations and forms of one of nature's interesting geometric works.

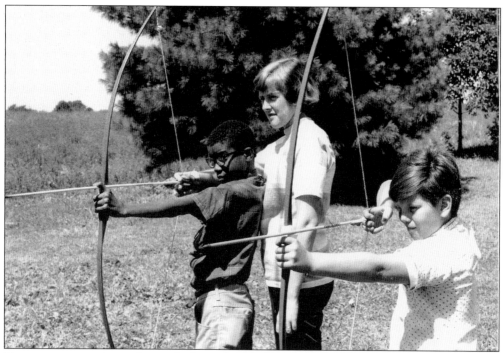

Two campers practice archery, which is just one of the activities available to the children at the camp.

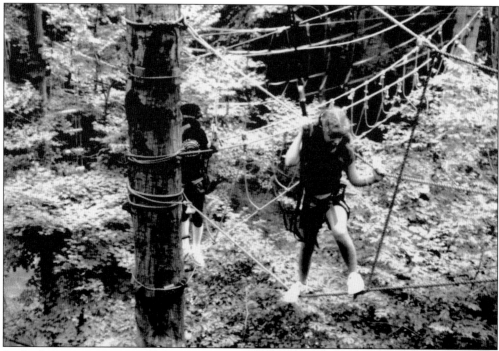

In the forests, campers traverse by rope walks rigged over rough grounds. They learn many skills in the wilderness that they are not exposed to in the city.

Campers are photographed here at an aquarium. The children's' experience at the settlement camp includes the physical, the social, and the education of the campers. Here, the theory is that campers learn by doing .

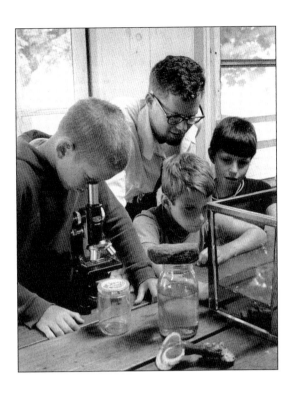

As a part of the camp experience, campers learn to play together. These two youngsters are in competition with other campers.

David Reed was one of the campers in the summer of 1941. The College Settlement Camp maintained a diversity of attendees, including persons of different ethnic, social, and cultural backgrounds.

Campers examine a nature exhibit. Again, the campers learn from a well-rounded schedule of activities during their stay at the College Settlement Camp.

Water is the place to be in the summer. These campers enjoy the water together as a group.

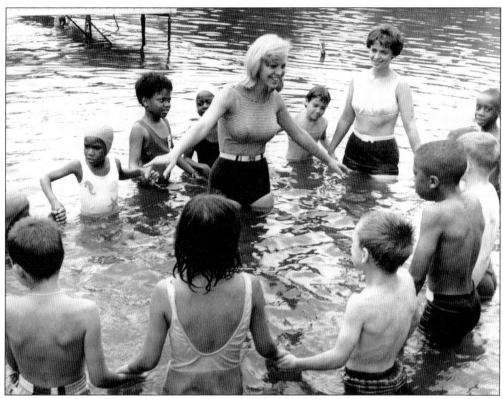

Camp counselors and swimmers gather near the lake for a refreshing swim on a hot summer day.

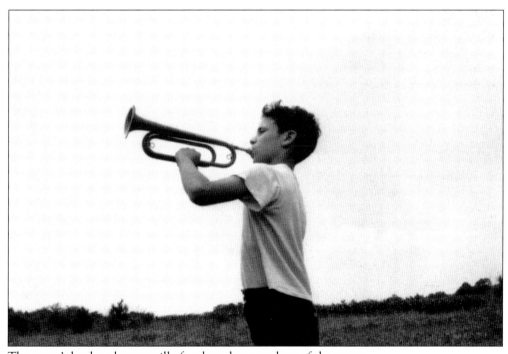

The camp's bugler plays reveille for the other members of the camp.

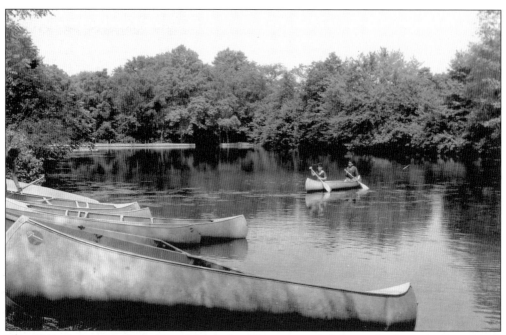

This 1941 photograph shows Friendship Lake. The man-made lake was built on the Pennypack headwaters by contributions from Friends Select School in 1933. Swimming and canoeing were popular activities there.

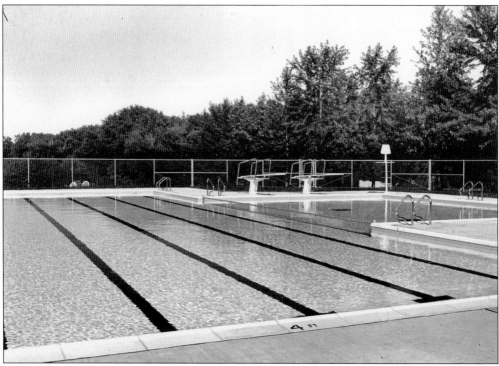

By 1966, development in nearby areas had caused such excessive pollution that the lake was replaced by a 200,000-gallon swimming pool, constructed at a cost of $65,000.

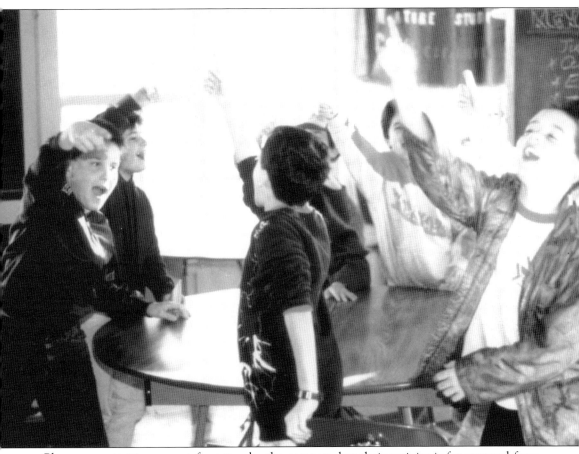

Classroom activities are not forgotten by the campers, but their activity is far removed from the winter classroom.

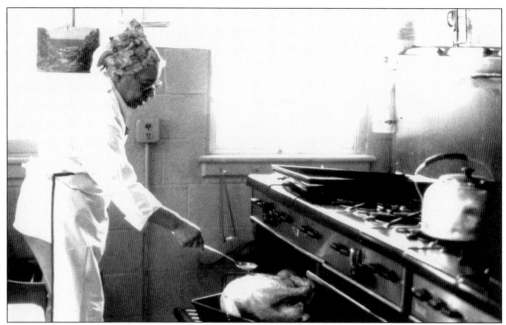

In an effort to be self-sufficient, the camp raised much of the food consumed by the campers. Here, a staff member is busy cooking turkey for one of the meals.

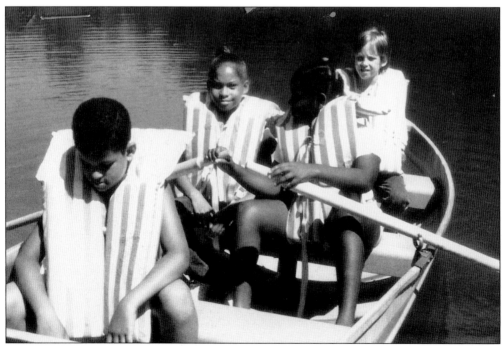

Photographed in the summer of 1941, these boys from Philadelphia are learning how to row a boat.

Eight

THE NAVAL AIR STATION

This is the logo of the Willow Grove Naval Air Station. The station is actually in Horsham. When the air base opened in 1942, the closest post office was in Hollowell. However, that post office was not capable of handling the large volume of mail generated by the base. The nearest post office that could handle the volume was Willow Grove. Thus, the base was designated as Willow Grove Naval Air Station.

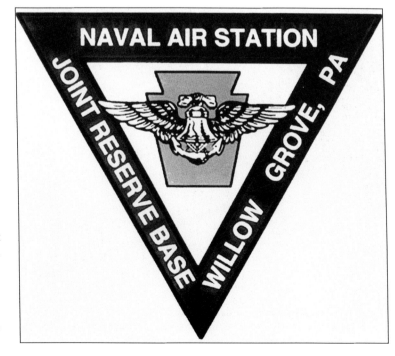

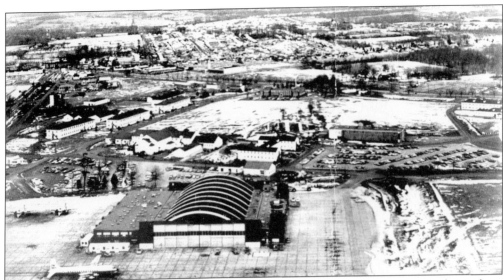

The naval air base is pictured in 1950. Both the hangar and the control tower shown here have since been replaced. The base continues to upgrade its facilities and keeps in a high state of readiness.

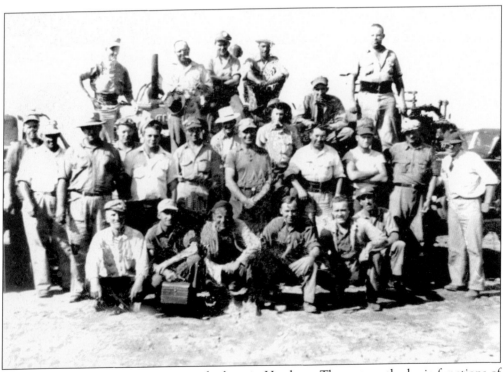

These men are the first navy men on the base in Horsham. They set up the basic functions of the navy as they took over Pitcairn Field to establish the supersecret antisubmarine facility in the existing factory building.

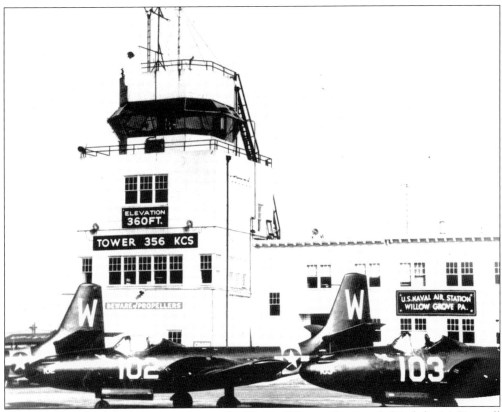

The control tower of the air base during the Korean War can be seen behind the McDonnell Phantom I FH-1—in line and ready for inspection on the tarmac.

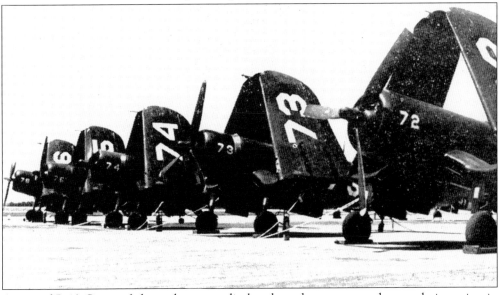

A row of P-40 Corsair fighter planes are displayed on the tarmac at the naval air station in 1950. With their folding wings, these airplanes were obviously capable of being used on navy aircraft carriers. At the naval air station, the planes were used for training purposes.

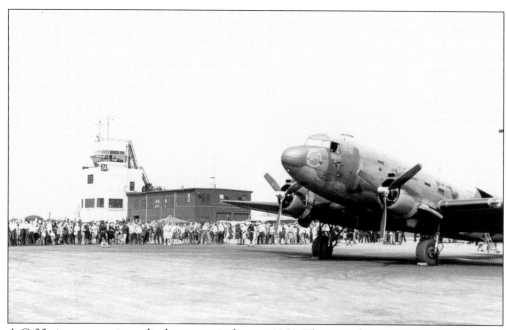

A C-30 air transport is on display at an air show *c*. 1950. These airplanes were used by the navy for all sorts of transport uses and were part of the training programs at the naval air station.

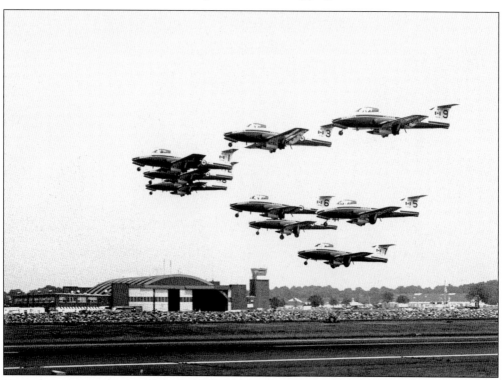

Nine planes participate in a flyby in 1960. This performance was part of the typical open house held by the naval base each year, an event that is normally attended by more than 300,000 spectators. The large crowd can be seen, along with the hangar which has since been replaced.

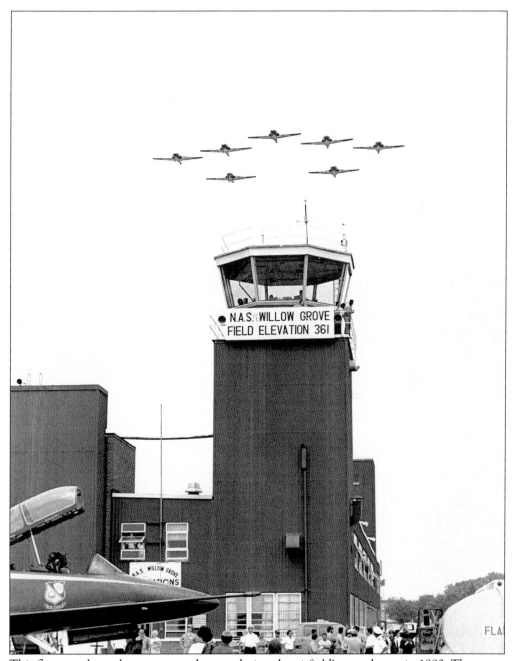

This flyover salutes the new control tower during the airfield's open house in 1990. The tower replaced the original control tower of the 1950s. The taller tower permitted better views of all areas around the field.

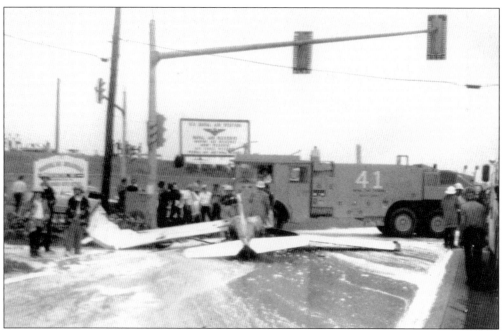

This crash of a naval base airplane occurred at the foot of the air base on Route 611. It was caused by the inexperience of the student pilot. At the base, 14 planes have crashes—several of them during the performances at the annual air shows.

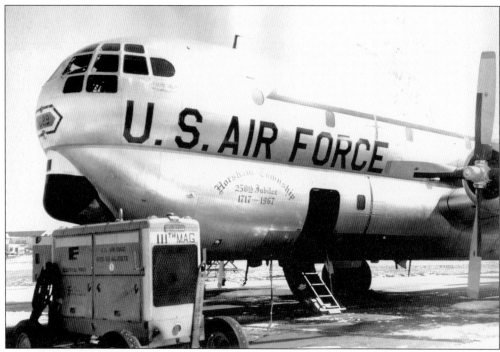

The Air Force C-54 Horsham, named after the township of Horsham, is parked on the tarmac at Willow Grove Naval Air Station. This image shows the joint utilization of the airfield as a base for use by all of the armed services.

This poster was printed for the commemoration of the 60th anniversary of the establishment of the Willow Grove Naval Air Station at Horsham. The navy took over Pitcairn Field in 1943 and has since established one of the largest joint bases for the defense of the United States.

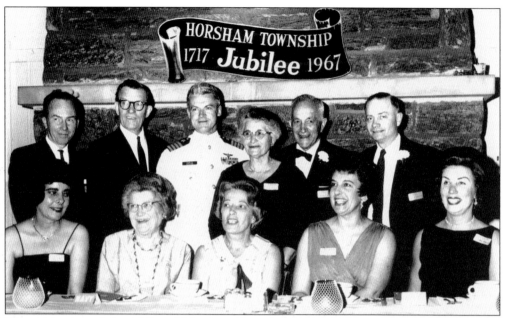

The celebration of the jubilee of Horsham Township (1717–1967) was held at the naval air base. From left to right are the following: (first row) Marion Ivey, Mrs. Charles Harper Smith, Mrs. William Terry, Betty Crawford, and Ethel Ballard; (second row) John McCarrol, William Terry, Capt. N. Charles, Lillian Lewis, Arthur Kuntz, and Richard Harvey III.

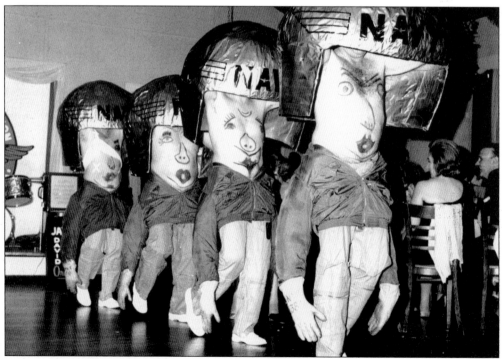

Four navy men with their chests painted as faces entertain the guests assembled at the celebration of Horsham's jubilee in 1967.

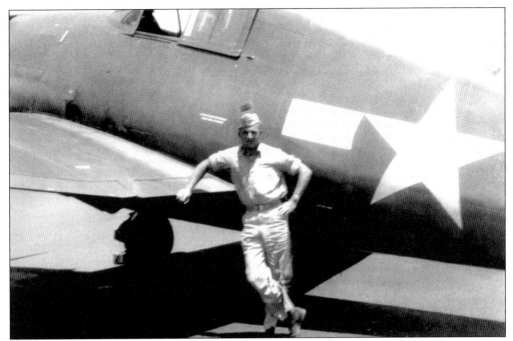

Lt. Raymond Markloff stands by his F-4-U on board the USS *Yorktown*. Markloff later became a leader in the Delaware Valley Historical Aircraft Association and the Wings of Freedom. He received the Bronze Cross for his gallantry in combat against the Japanese in World War II.

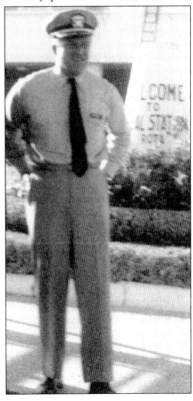

Capt. Raymond Markloff is pictured at the naval air station, standing by the airfield marker in 1961. He served in the navy reserve from 1942 to 1975.

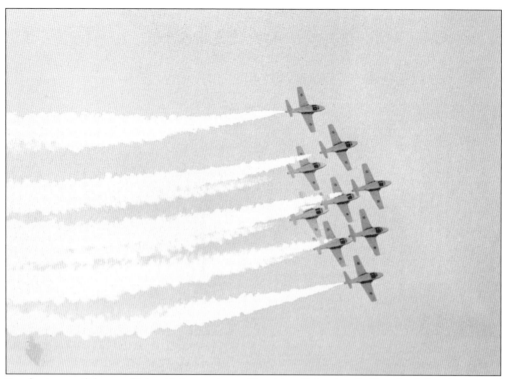

Smoke jets trail from a flight of planes above. Precision flying is a hallmark of the the annual air show.

At the end of World War II, military pilots and designers began to test captured enemy aircraft to find out just how good they were. These aircraft, including the first jet fighter to enter service, the ME 262, were brought stateside to test centers such as the Willow Grove Naval Air Station. After evaluation the airplanes were left to sit and deteriorate. Raymond Markloff formed the Delaware Valley Historical Aircraft Association to restore, maintain, and display these now historic planes.

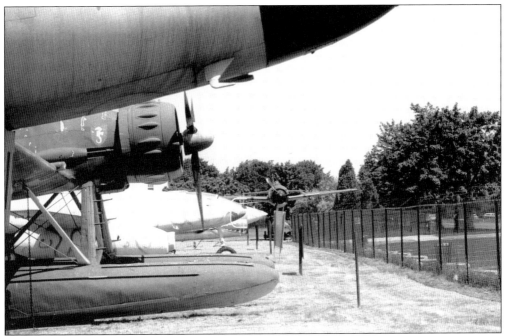

This is a part of the historic collection of airplanes displayed on Easton Road. From left to right are a Grumman Cutlass, a German Flotplane AR-196, a German Messerschmitt 262-1A, unidentified, and a Japanese N1K1 Kyofa.

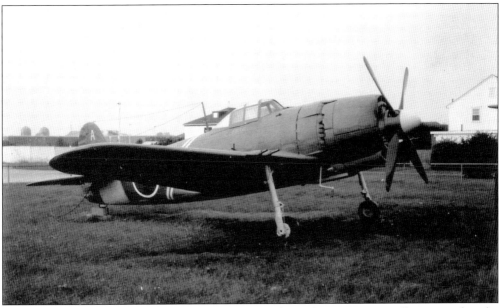

The famous Japanese Kamanicki George N1K2-J is shown here as it originally appeared in the historic airplane display. It is no longer on display. The airplane association's long-range goal is to build a restoration center, an educational facility, and a museum. The center would not only preserve these aircraft but also house a collection devoted to the history of aircraft and the aircraft industry of the Delaware Valley.

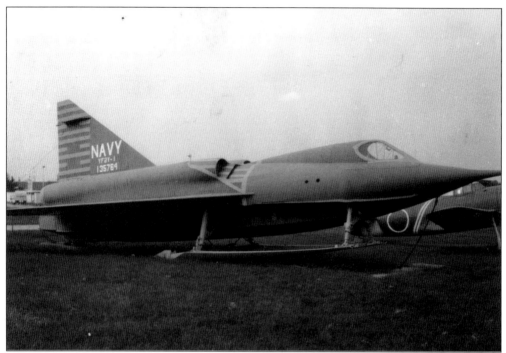

This YF2Y-1 Seadart was one of five planes built in the late 1940s as an experimental jet seaplane. This plane was completely repaired when it arrived at the naval air station.

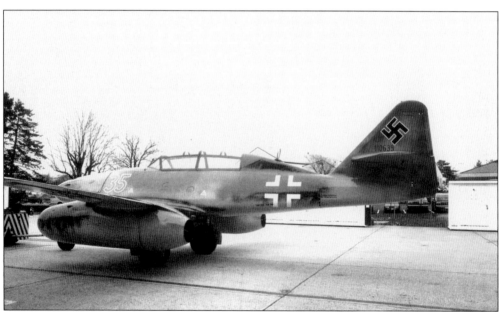

The German ME 262 B-1A Messerschmitt was a jet plane developed late in the war by Germany. It posed a great threat to the Allies when they attacked Germany in the later days of the war.

Nine

PITCAIRN

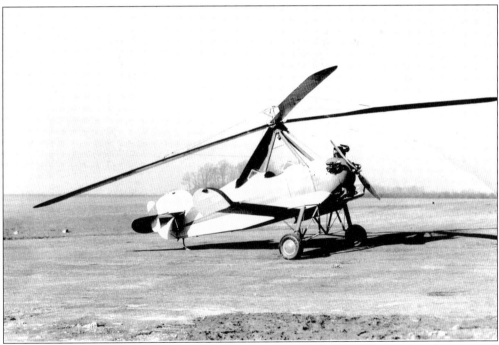

This is Harold Pitcairn's personal autogiro, built in 1931. Because of Pitcairn's enthusiasm and his personal commitment to the invention, his offices received deposits and advanced orders from individuals and corporations seeking the convenience, safety, and publicity that seemed to accompany almost every autogiro flight. This autogiro was used by Harold Pitcairn to fly from his home in Bryn Athyn to his new field in Horsham. The Pitcairn Fleetwing was actually the first plane that Harold Pitcairn built in the small building near Byberry Road in Bryn Athyn. He quickly outgrew the field in Bryn Athyn, with its short runway, making the move to Horsham necessary. After moving to Horsham, Harold Pitcairn acquired the Spanish autogiro patents and began his research and development of his version of the autogiro.

RENEWAL

UNITED STATES DEPARTM[

Approved School

This is to certify that ___ PITCAIRN AVIATION

Located at ___ PITCAIRN FIELD, WILL

Approved ___ LIMITED COMMERCIAL-PRIVATE

Pursuant to the authority of Sec. 3-D of the Air (
February 28, 1929, and the School Suppleme
provisions of which are made a part hereof (

BY DIRECTION OF THE SECRETARY.

T OF COMMERCE

rtificate

., INC.

OVE, PA. *is an*

UND AND FLYING *School*

merce Act of 1926, as amended
Air Commerce Regulations, the
hough written herein.

ISSUED _ May 28, 1930.

EXPIRES _ May 28, 1931.

Clarence M. Young

Assistant Secretary of Commerce
for Aeronautics.

On May 28, 1930, the U.S. Department of Commerce issued this approved school certificate to Pitcairn Aviation of Pennsylvania for a limited commercial-private ground and flying school. The certificate allowed Harold Pitcairn to operate a school open to the public on his formerly private airfield. Pitcairn expanded the field to include the manufacture of Mailwing airplanes and developed the mail service on the East Coast, which led to the establishment of Eastern Airlines. At the same time, Pitcairn developed what he believed was the future of aviation: his autogiro. To promote his plane, he developed programs with Amelia Earhart and gave public tours in his autogiro.

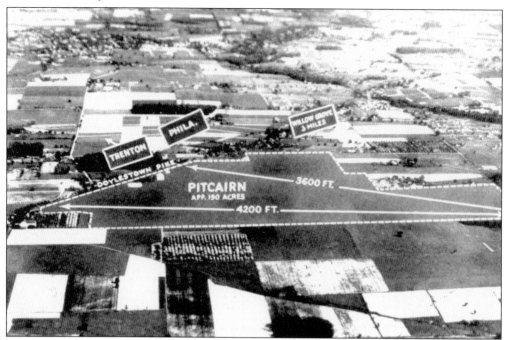

This aerial photograph of Pitcairn Field indicates the length of the open runways to be 3,500 and 4,000 feet each. All buildings on the site were demolished for the open space. Harold Pitcairn purchased three farms in 1925. He bought Jacob Megargee's 70-acre farm for $60,000; Charles A. Schacter's 72-acres for $58,000; and Jonathan Stackhouse's 126-acres for $133,000. The U.S. government paid $278,278 for all of Pitcairn's land in 1945.

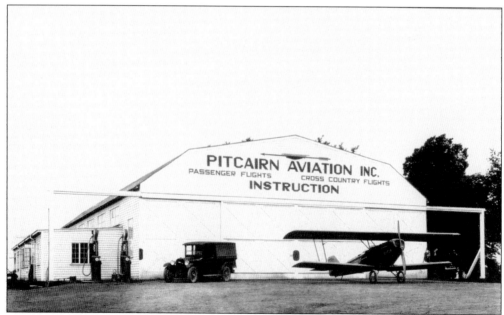

Pictured c. 1925 is the Pitcairn hangar with the Mailwing airplan, developed at the field, parked in front. The development of this airplane was the start of Eastern Airlines and of the mail postal service on the East Coast.

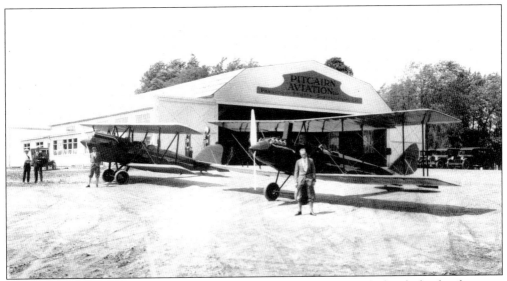

The Pitcairn Mailwing PR-3 is shown in front of the factory. Not satisfied with the development of the Mailwing airplane, Harold Pitcairn developed the autogiro. He became fascinated with vertical takeoff and flight. The Pitcairn Mailwing was built for the U.S. government and for mail delivery contracts on the East Coast.

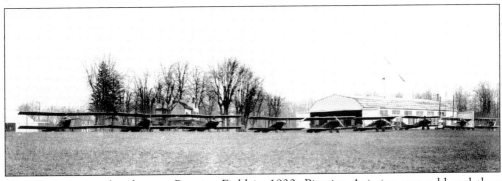

New airplanes are lined up at Pitcairn Field in 1930. Pitcairn Aviation was sold and then renamed Eastern Air Transport, one of several carriers that developed and flourished as a result of the Air Mail Act of 1934.

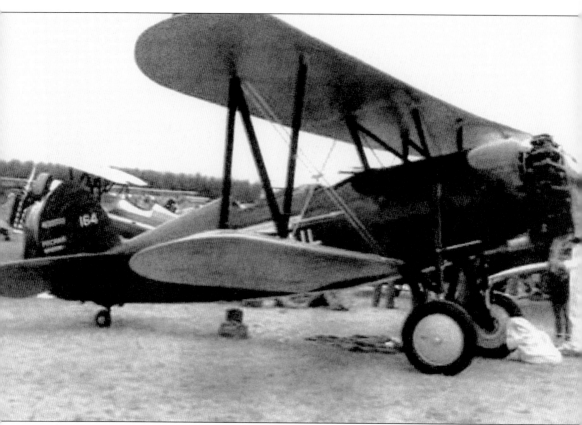

The Pitcairn PA-8 Super Mailwing (NC10753) was typical of the development of the airplane for the airmail service. Clement Keys, a former financial editor of the *Wall Street Journal*, decided to purchase the airline known as Pitcairn Aviation. Keys then sold Pitcairn to North American Aviation, and the airline's name was changed to Eastern Air Transport. The airline grew, and the airmail transports were expanded to include Atlanta, Miami, Boston, and Richmond.

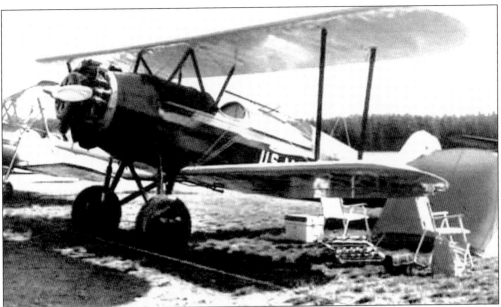

Here is another Pitcairn PA-6 Super Mailwing (N15307). This plane was restored to show the beauty of the Pitcairn Mailwing and to show the development of the early days of Eastern Airlines. Eddie Rickenbacker became president of the newly formed Eastern Airlines. Through Rickenbacker, the company also became the world's first airline to begin mail service using autogiros.

AIRPLANE FALLS IN TRIAL FLIGHT

Left Wing of Pitcairn Machine Buckled When Only Up 25 Feet

BUILT AT BRYN ATHYN

Just twenty four hours after it had been christened, the "Fleetwing," Pitcairn Flying Field's new airplane, was damaged to the extent of a broken wing Wednesday when forced to make a landing at the Bryn Athyn field after an attempted trial flight. Its pilot, Lieutenant James G. Ray, cut his nose and was taken to the Abington Memorial Hospital for treatment.

The plane which Lieutenant Ray was testing was the PA-1 and it was scheduled to fly in the Pulitzer races today. It was constructed at the Pitcairn Field and was the first commercial airplane ever built in Pennsylvania.

After waiting all day for favorable air conditions and in the meantime making the final tests of the mechanism the plane was finally started shortly after 5 o'clock With the engine running perfectly and the plane in apparent good condition it glided from the ground amid the cheers of the aviators and the men who had worked on its construction

No sooner had it left the ground than trouble developed. The left wing was seen to sag and it was evident that a perfect balance would not be obtained. Employing every means known to the expert flier, Lieutenant

Early in the development of the autogiro, there were airplane crashes. This article in the local Jenkintown paper, reporting news in Horsham, tells of the crash of an autogiro in 1925. Not fatal, the crash was attributed to the failure of the left wing. Such crashes occurred but did not diminish enthusiasm for the development of the vertical takeoff airplane. Harold Pitcairn knew of the success and failure of the early tests of the Cierva C-7 in France and England. Not afraid to pursue his experiments, he continued in spite of these discouragements.

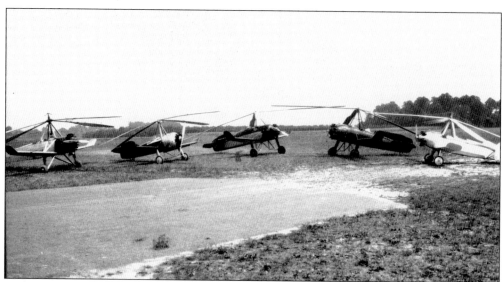

The Fleetwing Cierva C-7, left, was built in England from Spanish designs. This Fleetwing was the first to fly in the United States. It provided Harold Pitcairn with the prototype of what he believed to be the future in aviation. Pitcairn bought his first autogiro and housed it at his family home in Bryn Athyn. Later, he moved his whole operation to his airfield in Horsham.

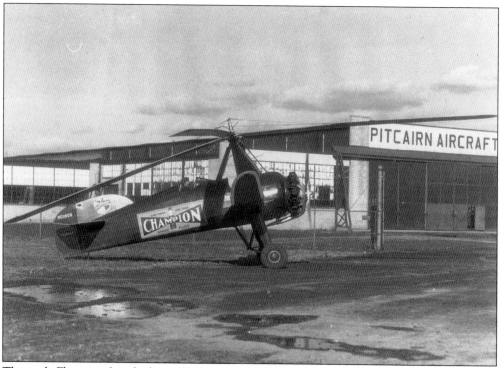

This early Fleetwing has the logo of Champion spark plugs on the fuselage. The Fleetwings were often sold to large corporations as a means for Harold Pitcairn to raise capital for his fledgling airplane manufacturing business.

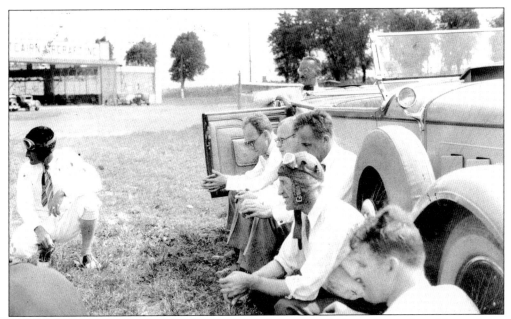

These men were involved with adjustments and the autogiro's testing and problem solving on a daily basis. Leaders of the plane's development, they are, from left to right, James G. Ray, chief pilot; Harold Pitcairn; G.S. Childs, vice president; Ed Asplundh, vice president of manufacturing; John Paul "Skipper" Lukens, test pilot; and Paul Stanley, assistant engineer. For them, an outdoor conference was unusual, and why they were together by the Packard remains a mystery.

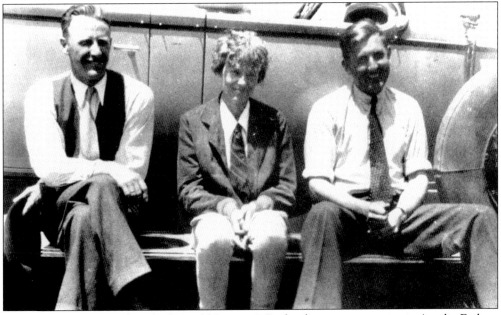

Sitting on the running board of Harold Pitcairn's Packard touring car, aviatrix Amelia Earhart awaits her turn to fly the autogiro in 1931. With her are instructors Jim Faulkner, left, and Jean Paul Lukens, who in December 1930 had provided her with a 15- to 20-minute flying lesson. Harold Pitcairn used Earhart's fame to promote his autogiro.

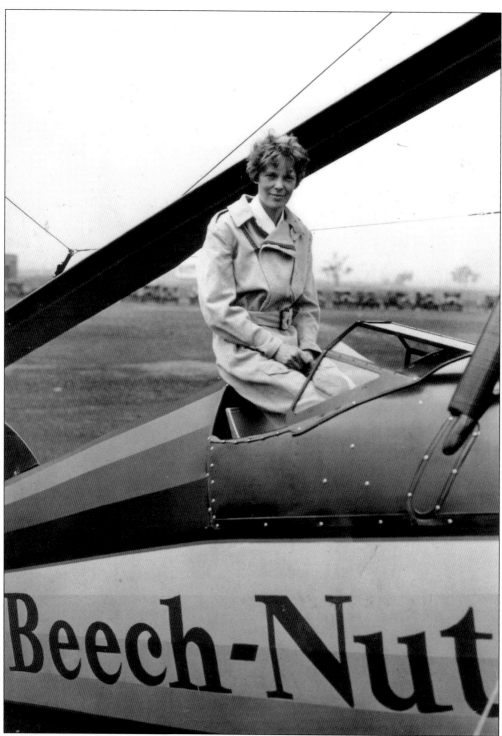

Amelia Earhart waits to take off in the Beech-Nut autogiro. Earhart soloed at Pitcairn Field on December 19, 1930, thus becoming the first female autogiro pilot in America. Now, she was poised to make the first transcontinental autogiro flight, sponsored by Beech-Nut.

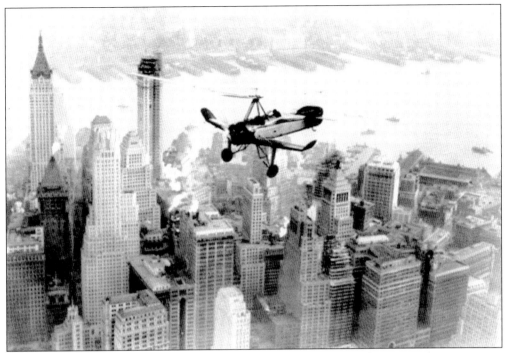

Brokered by her husband, George Putnam, who was known for his acumen at garnering publicity, Amelia Earhart accepted the Beech-Nut Packing Company's offer to fly its PCA-2 autogiro coast-to-coast, with the company's logo painted on the side.

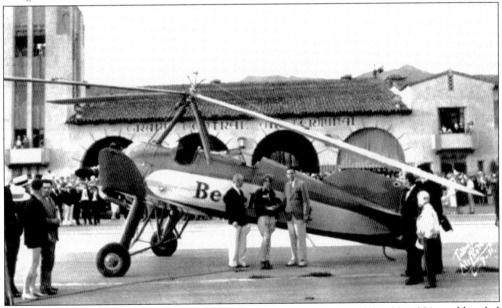

Amelia Earhart left Newark, New Jersey, in the Pitcairn autogiro on May 29, 1931, and headed west. She made as many as 10 landings per day, interacting with the airport crowds and handing out samples of Beech-Nut chewing gum. She arrived in Oakland, California, on June 6, 1931, only to discover that legendary pilot John M. Miller had eclipsed her transcontinental flight by arriving in San Diego from Pitcairn in an autogiro on May 28, 1931.

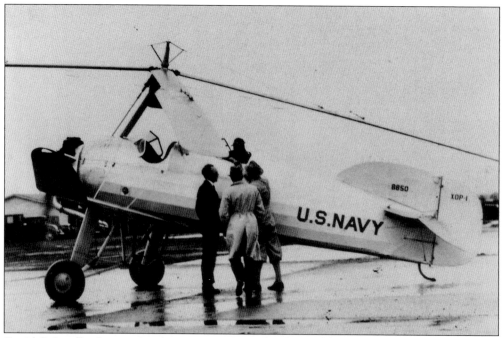

David S. Ingalls, the navy's assistant secretary and only World War I ace, published an article in *Fortune* entitled "Autogiros D Missing Link." In the article, Ingalls asserted that "Inventor Cierva and Impresario Pitcairn offer the most promising new flying machine in the thirty-year history of aviation." Harold Pitcairn and his associates were awarded the prestigious Collier Trophy for the greatest achievement in American aviation for 1930. With all this in mind, it was no wonder that the navy ordered a number of Pitcairn's autogiros.

SALUTE TO AMERICA

JULY 2, 3, 4, 1976

SCHEDULE OF EVENTS

This air show advertisement uses the autogiro as a feature. The autogiro was not forgotten in spite of the later success of the helicopter. Many of the important advances in the development of the helicopter were directly related to the early designs of the autogiro.

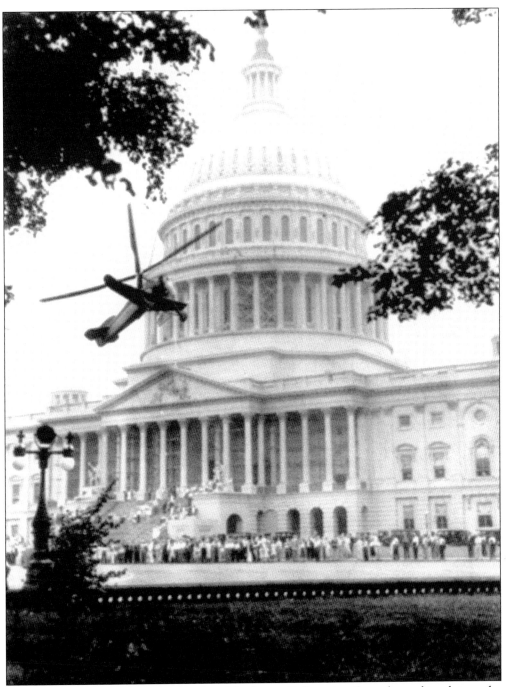

In Washington, D.C., an autogiro piloted by James G. Ray rises from the parking lot on the east side of the Capitol Building and skims over the top of the Senate Office Building. In 10 minutes' time, the aircraft carried Sen. Hiram Bingham to Burning Tree Country Club, generally an hour-long trip. This flight was not the only autogiro event to capture public attention.

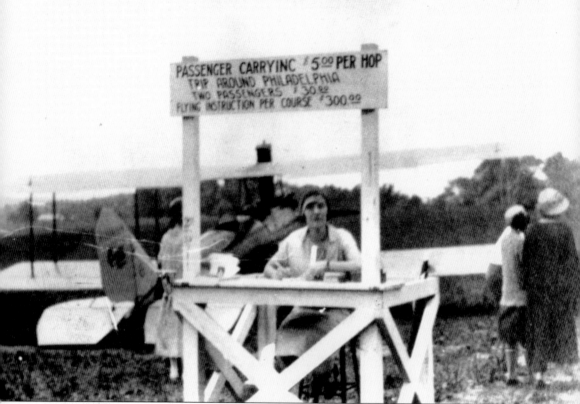

PASSENGER CARRYING $5.00 PER HOP
TRIP AROUND PHILADELPHIA
TWO PASSENGERS $30.00
FLYING INSTRUCTION PER COURSE $300.00

This ticket sales booth sold tickets to fly in the Curtis Oriole. Harold Pitcairn was a great publicist for his new airplanes and used the flights about the city and countryside as a means of promoting the engineering phenomenon. Tickets for the flight were purchased with cash only; there were no credit cards at the time.

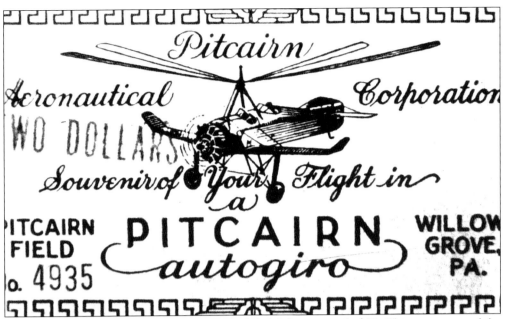

The ticket price for a flight for two around Philadelphia was only $30. This was a part of the sales promotion that Harold Pitcairn organized to sell his autogiro. A local trip cost only $5.

This is the current Tinius Olsen building on Easton Road, which is still on the naval airfield. During World War II, the building was used for the manufacture of autogiros and gliders. The autogiros shown here were due for shipment to England in 1940.

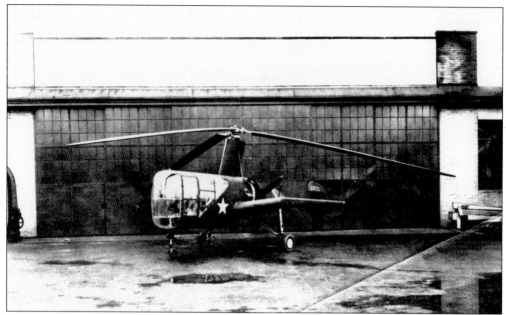

This is the only pusher autogiro made by Pitcairn. The motor and propeller are mounted in the rear of the airplane. It was an experimental army model of 1944, which resembles the helicopter of today. The pilot has a free and uninterrupted view of the airspace ahead, including both sides of the airplane.

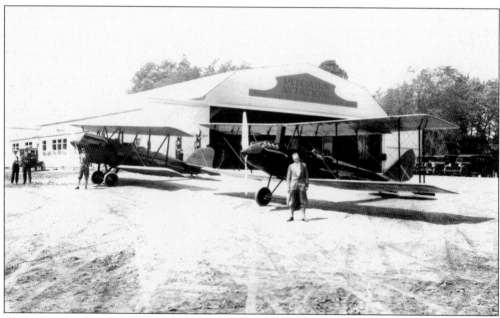

The best advertising for Harold Pitcairn was the number of celebrities who were attracted by him to fly his autogiros. Amelia Earhart was one of the most prominent. Others included Charles Lindbergh and Eddie Rickenbacker.

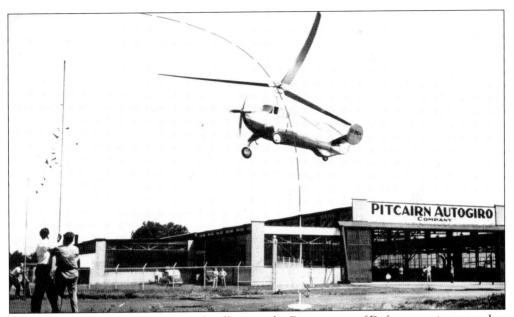

A Whirlwing autogiro does a jump takeoff to pass the Department of Defense requirements that the airplane must rise vertically 20 feet and then fly horizontally as measured by the wooden pole set in the ground. This 1941 demonstration showed the vertical jump and the transition to horizontal flight of the Whirlwing.

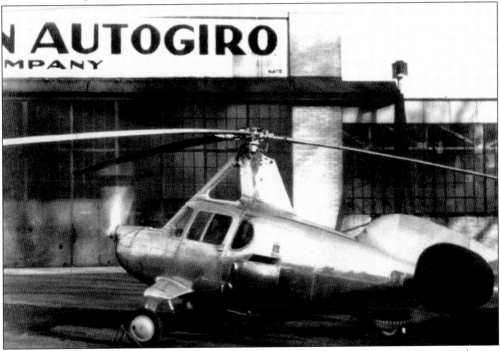

The 1940 autogiro PA-36 could be driven on the road. In an attempt to make air travel more attractive to the public, Harold Pitcairn designed this autogiro as an advanced automobile with dual steering wheels in the front and a single propulsion wheel in the rear. The overhead rotor blades were folded in when the autogiro was traveling on the road.

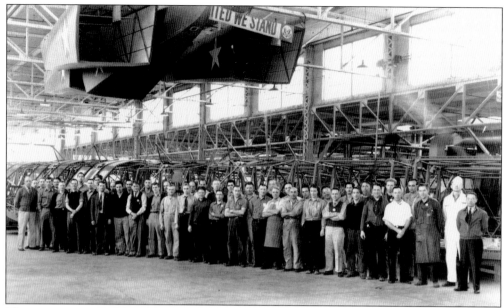

This company employee photograph at the Pitcairn-Firestone factory dates from 1945. The factory built troop-carrying gliders as well as early helicopters. The gliders were known as GR-4 or XR-4. They were designed by the Pitcairn staff.

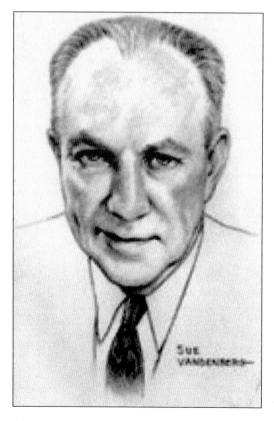

Harold Pitcairn (1897–1960) was a pioneer in the development of the autogiro—a forerunner of the helicopter. He outgrew his flying field in Bryn Athyn and purchased 191 acres of farmland in 1925 along Easton Road in the vicinity of Graeme Park. The new Pitcairn Field remained in operation for testing autogiros until 1945, when the U.S. Navy purchased the field. Today, the base is still in operation, and—with the acquisition of additional land and the expansion of facilities—has become one of the largest naval air stations in the nation, serving all branches of the services.This sketch was done in 1926.

Ten

THE WHITEMARSH
MEMORIAL PARK

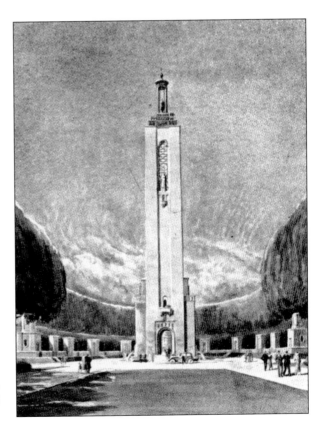

According to literature of the times, the "Tower of Chimes, a round terminal of the mall, and the virgin woods form an impressive background." The appearance is achieved in the final placement of the Tower of Chimes. Shown here is architect Paul Cret's sketch of the memorial tower.

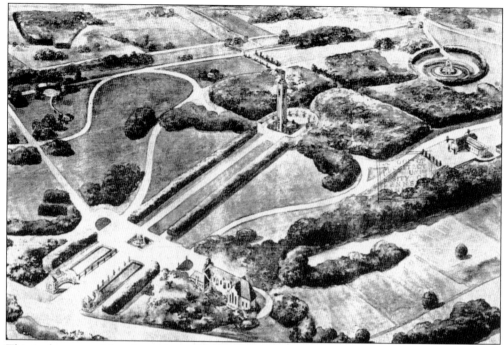

This is the memorial park envisioned by Paul Cret in 1928, "showing the woodland, principal structures, courts, driveways, fountains and lakes." The design was used in creating the Whitemarsh Memorial Park.

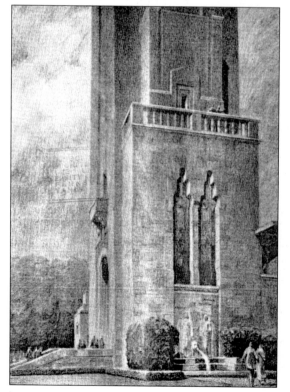

This is Paul Cret's sketch of the base for the Tower of Chimes, "in which will be housed a gallery of artistic memorials." Unfortunately, the idealistic picture was never achieved. A dumpster was placed where the fountain is shown. Many of the design features of the tower were postponed.

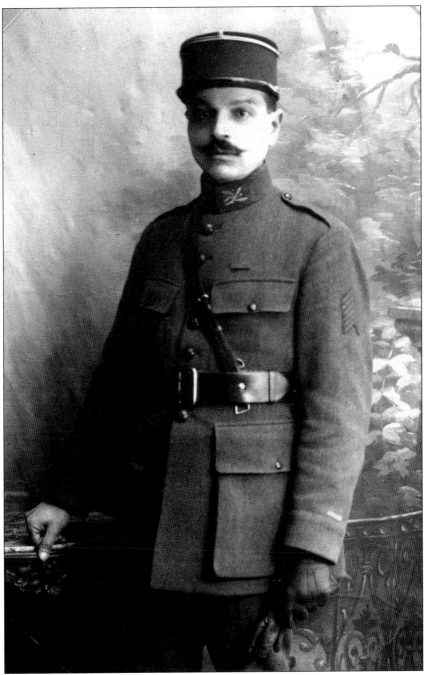

The architect of Whitemarsh Memorial Cemetery, Paul Philippe Cret, poses for a portrait while serving in the French army. He was born in Lyons, France, in 1876 and was trained at the L'Ecole des Beaux Arts, in Paris, France. In 1903, the distinguished architect was invited to teach architecture at the University of Pennsylvania, where he remained until his retirement in 1937. Cret designed cemeteries in France for the United States during World War I. He established an architectural firm in Philadelphia, which became Harbeson, Hough, Larsen, Livingston.

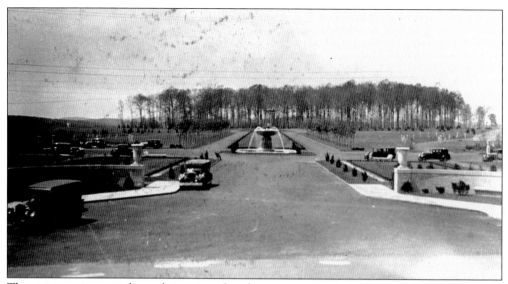

The main entrance to the park is pictured under construction in 1931. Note that the mall has been formed and planted, but the Tower of Chimes has not been started. The main fountain is in place and operating. The chapel, administration hall, and horticultural hall have not been started. The automobiles shown were used to date this photograph.

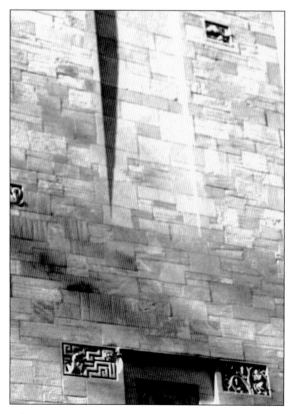

This *c.* 1931 photograph shows the parklike design that was the trademark of Paul Cret. Whitemarsh Memorial Park is blessed with these features of smooth limestone that act as a point on the landscape, bringing the viewer back to reality.

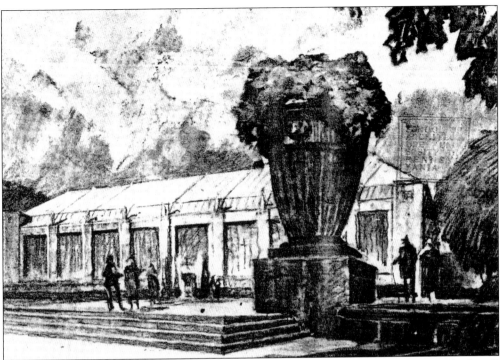

The horticultural hall, shown in this sketch, was designed to be "another feature which will distinguish the Whitemarsh Memorial Park." Unfortunately, this building was proposed but never constructed.

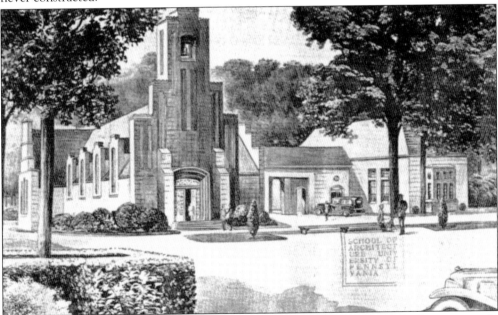

Shown is architect Paul Cret's sketch of the chapel, which was designed to be built conveniently close to the entrance of the park. Unfortunately, the chapel was never constructed. However, the administration building was completed. The parklike atmosphere furnished by the trees continues to this day.

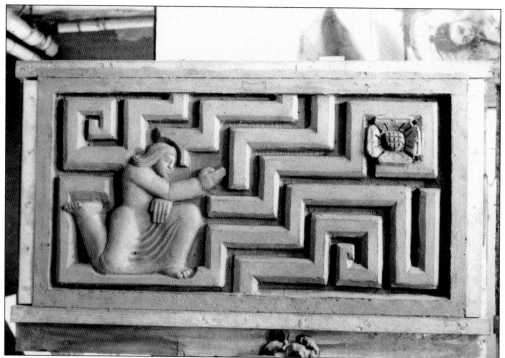

Paul Cret commissioned the famous French sculptor Jean De Marco to design various pieces to be part of the park. The work was designed in France by De Marco and reviewed in Philadelphia by Cret. "We are worried about the repetition of the bends at the center," Cret said of this design, commenting on the work before the stone was cut.

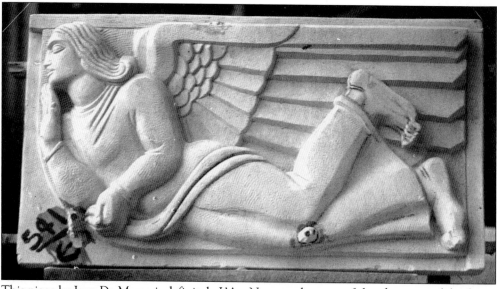

This piece by Jean De Marco is definitely L'Art Nouveau because of the character of the figure and its stylistic manner. Reviewing the design before it was carved, Paul Cret wrote that this one was too complicated. However, he did not ask that it be redone. The work is currently on the wall as it is shown here.

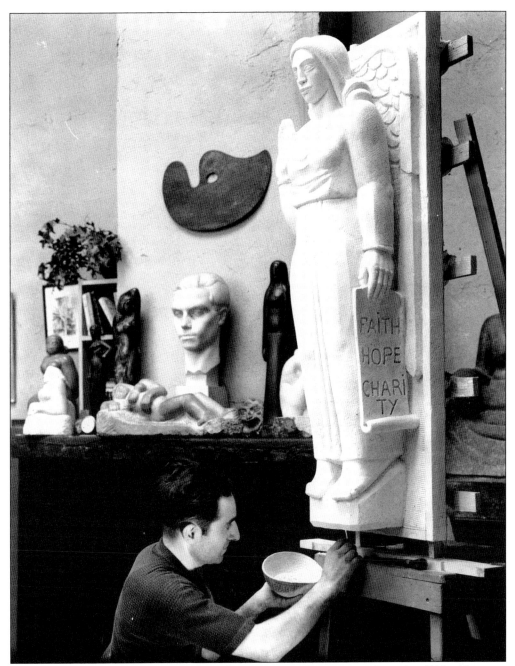

In France, sculptor Jean De Marco shows his mastery in this figure in the style of L'Art Nouveau for the review of Paul Cret in Philadelphia. Note the English words incised in the scroll: "FAITH HOPE CHARITY." The figure is a plaster sketch of the sculpture that De Marco intended as the dominant piece high up on the tower. It was to be carved of stone by the mechanics at the quarry and shipped to Philadelphia. In the background are other examples illustrating the mastery of De Marco in various media.

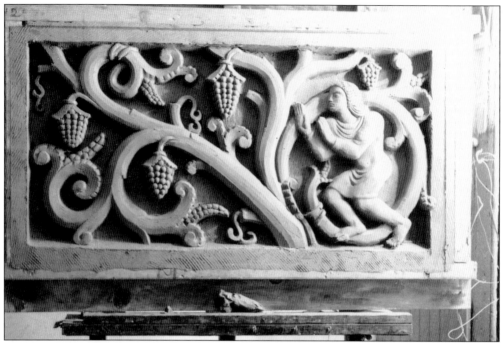

The piece shown here is definitely L'Art Nouveau because of the character of the figure and its stylistic manner. Sculptor Jean De Marco again showed his mastery of the medium to architect Paul Cret before carving the figure. Cret said this one had to be redone because the tree trunk appeared too heavy.

The combination of the figure and the stylistic background creates an allegorical statement of the angel and the surround of a piece of stone. It was ultimately built into the stone wall as a decorative piece in a bland wall. Again, the influence of L'Art Nouveau is apparent in the stylistic figures.

New York city 31 Octobre 1937.

OCT 12 1937

Cher Monsieur Cret,

 Ci joint les photographies du lion, je serai très heureux de connaître votre point de vue à son sujet car avec vos yeux frais pourriez peut être voir quelques retouches à faire qui m'echappent, et au cas que vous le trouviez satisfaisant de savoir si je peut l'expediez à la Ingall stone Co.

 Agreez je vous prie mes salutations empressées

Jean De Marco

[handwritten note in French]

On October 12, 1937, sculptor Jean De Marco wrote to architect Paul Cret in New York City. Translated, the letter reads as follows: "Dear Mr. Cret, The attached photographs of the lion, I would be very happy to know your point of view on the subject, because with your keen eyes perhaps you can see some retouching/corrections to make that have escaped me/that I haven't noticed, or if you find it satisfactory I wanted to know ifI can send it off to the Ingall Stone Company. Yours most sincerely, Jean De Marco." Cret responded: "The lion is very good. Send it to the Ingall Stone Company." In this manner, the two designers corresponded. It is obvious that the sculptural artist had a great respect for the architectural designer.

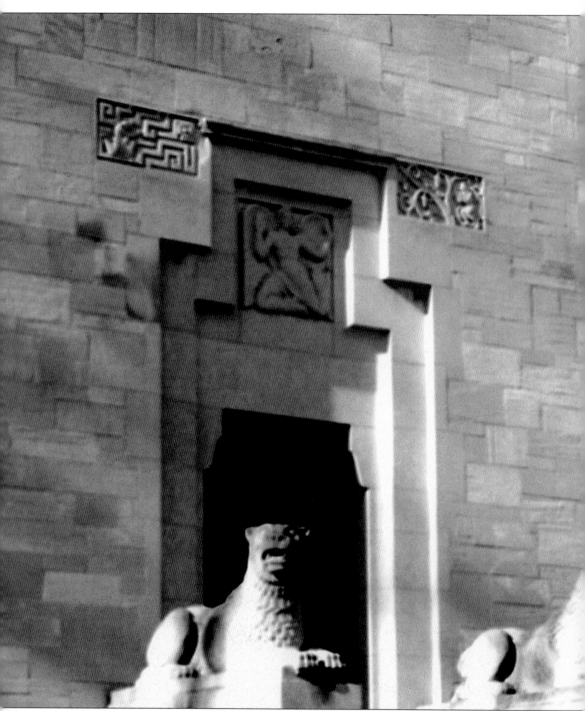

Shown here are the lions described in the correspondence between Paul Cret and Jean De Marco in 1937. They grace the entrance to the Tower of Chimes. In a manner consistent with the architectural combination of Cret and De Marco, the two lions dominate the entrance to the stairway. Note that the correspondence is dated 1937 and that Cret began his work in 1927.

The entrance to the administration building includes the addition of a Colonial portico. The chapel, as shown in the sketch on the bottom of page 119, is not incorporated in the final design of this building. However, the side of the administration building, shown below, follows architect Paul Cret's design.

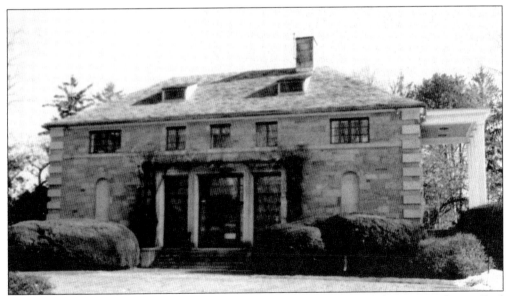

The side of the administration building is typical of the designs of the great architect Paul Philippe Cret. Buildings he designed are found from Texas to Philadelphia, as well as in his native France. Cret became a leader during the period of architectural upheaval that was the change from Classical architecture to the modern works of Frank Lloyd Wright.

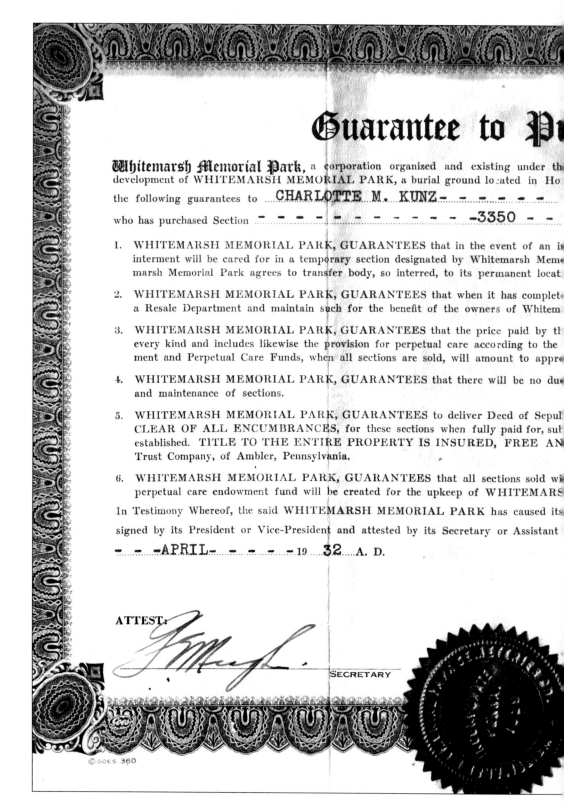

Guarantee to P

Whitemarsh Memorial Park, a corporation organized and existing under th
development of WHITEMARSH MEMORIAL PARK, a burial ground located in Ho

the following guarantees toCHARLOTTE M. KUNZ- - - - - -

who has purchased Section - - - - - - - - - - - -3350 - -

1. WHITEMARSH MEMORIAL PARK, GUARANTEES that in the event of an i
 interment will be cared for in a temporary section designated by Whitemarsh Mem
 marsh Memorial Park agrees to transfer body, so interred, to its permanent locat

2. WHITEMARSH MEMORIAL PARK, GUARANTEES that when it has complet
 a Resale Department and maintain such for the benefit of the owners of Whitem

3. WHITEMARSH MEMORIAL PARK, GUARANTEES that the price paid by th
 every kind and includes likewise the provision for perpetual care according to the
 ment and Perpetual Care Funds, when all sections are sold, will amount to appre

4. WHITEMARSH MEMORIAL PARK, GUARANTEES that there will be no due
 and maintenance of sections.

5. WHITEMARSH MEMORIAL PARK, GUARANTEES to deliver Deed of Sepul
 CLEAR OF ALL ENCUMBRANCES, for these sections when fully paid for, sub
 established. TITLE TO THE ENTIRE PROPERTY IS INSURED, FREE AN
 Trust Company, of Ambler, Pennsylvania.

6. WHITEMARSH MEMORIAL PARK, GUARANTEES that all sections sold wi
 perpetual care endowment fund will be created for the upkeep of WHITEMARS

In Testimony Whereof, the said WHITEMARSH MEMORIAL PARK has caused its

signed by its President or Vice-President and attested by its Secretary or Assistant

- - -APRIL- - - - -19..32....A. D.

ATTEST:

_____ SECRETARY

© GOES 360

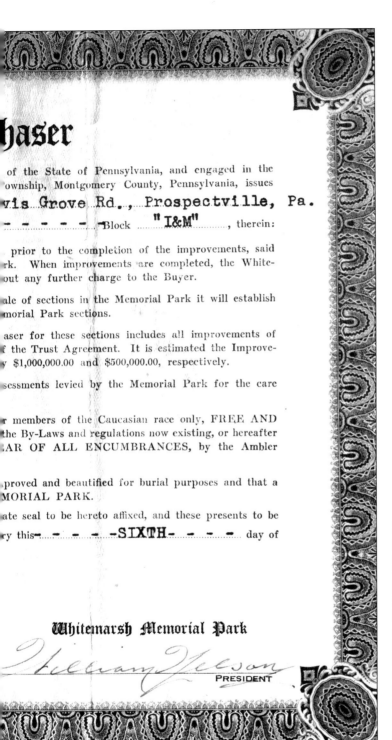

haser

of the State of Pennsylvania, and engaged in the
ownship, Montgomery County, Pennsylvania, issues

vis Grove Rd., Prospectville, Pa.

- - - - - - Block "I&M", therein:

prior to the completion of the improvements, said
rk. When improvements are completed, the White-
out any further charge to the Buyer.

ale of sections in the Memorial Park it will establish
morial Park sections.

aser for these sections includes all improvements of
the Trust Agreement. It is estimated the Improve-
y $1,000,000.00 and $500,000.00, respectively.

sessments levied by the Memorial Park for the care

r members of the Caucasian race only, FREE AND
the By-Laws and regulations now existing, or hereafter
AR OF ALL ENCUMBRANCES, by the Ambler

proved and beautified for burial purposes and that a
MORIAL PARK.

ate seal to be hereto affixed, and these presents to be
y this - - - - -SIXTH- - - - - day of

Whitemarsh Memorial Park

William Nelson
PRESIDENT

Shown here is a
guarantee for purchasers
of cemetery plots in the
Whitemarsh Memorial
Park. Dated April 1932,
it guarantees that the
burial ground will be
completed, improved, and
beautified; that there will
be no dues or assessments;
that approximately $1
million will be set aside
for improvements and
approximately $500,000
for perpetual care; and that
a "Deed of Sepulchre, for
members of the
Caucasian race only"
will be delivered.

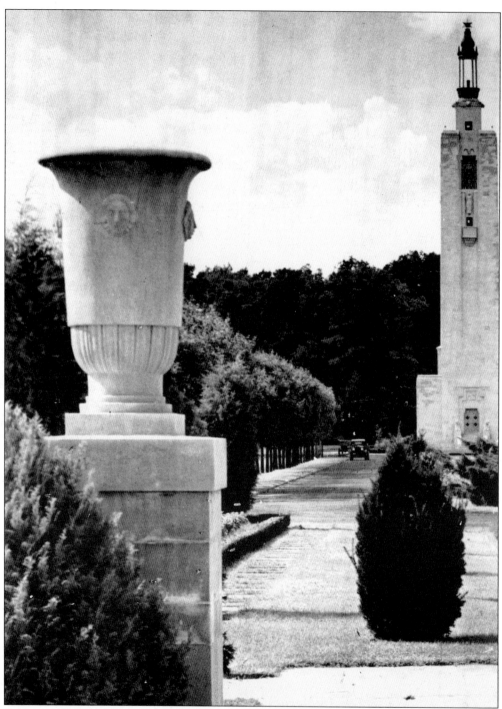

Taken in 1931, this classic photograph shows the formal garden–funeral urn in the foreground and the mall stretching beyond. The tower serves as a terminus of the composition. In this design, architect Paul Cret reveals his L'Ecole des Beaux Arts training. However, his newfound freedom in the breaking of traditions is not apparent here, and L'Art Nouveau is evident only in the details.